BARNSTAPLE & AROUND

THE POSTCARD COLLECTION

Denise Holton & Elizabeth J. Hammett

AMBERLEY

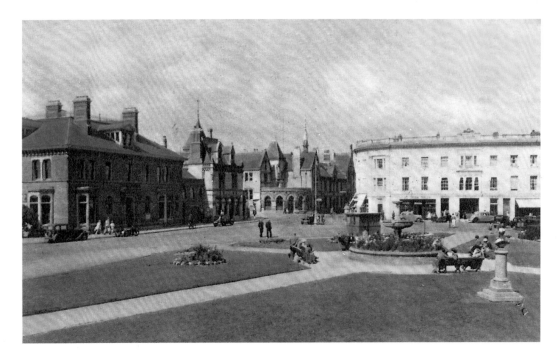

Lovely hand-tinted early postcard of the Square, Barnstaple.

First published 2016

Amberley Publishing
The Hill, Stroud, Gloucestershire, GL5 4EP
www.amberley-books.com

Copyright © Denise Holton and Elizabeth J. Hammett,
2016

The right of Denise Holton and Elizabeth J. Hammett
to be identified as the Authors of this work has been
asserted in accordance with the Copyrights, Designs and
Patents Act 1988.

ISBN 978 1 4456 4289 5 (print)
ISBN 978 1 4456 4302 1 (ebook)

British Library Cataloguing in Publication Data.
A catalogue record for this book is available from the
British Library.

Typesetting by Amberley Publishing.
Printed in Great Britain.

CONTENTS

INTRODUCTION

The history of Barnstaple is a long and distinguished one. This ancient town has seen a great deal of change over the centuries; it has been through good times and bad, experienced prosperity and hardship, seen great change, but remained the same in so many ways. The story traditionally begins in AD 930 – the date that Barnstaple claimed to have received its first charter. The basic layout of the town was already in place. Boutport Street and the High Street were in existence, with a strong defensive wall surrounding the town. Barnstaple was one of four 'burhs' and was also important as a centre of commerce. By 1066 Barnstaple was a well-established town, later receiving an entry in the Domesday Book of 1086. The late sixteenth and early seventeenth centuries were exciting periods in Barnstaple's development. The great quay was built, leading to a significant increase in trade. In 1603, work began on the building of a new quay to cope with the ever expanding trade.

In 1642 the Civil War began – Barnstaple changed hands four times before its end. In the years that followed, Barnstaple settled down to consolidate its position as a port and industrial centre and in the eighteenth century Queen Anne's Walk was created in its present form as a merchants' exchange. In 1710, the first proposals were made to create a formal square. In 1825 steam was used for the first time in Barnstaple to power lace bobbins at the Derby Mill factory and a year later the present Guildhall was built, replacing the Old Guildhall (actually Barnstaple's second). During the first half of the century, the population had doubled to 8,500. By 1835 the town's boundaries had been extended to include Pilton and Newport, then in 1854 the Barnstaple–Exeter railway opened. The continued silting of the River Taw resulted in the decline of Barnstaple as a port, and, as time passed, the majority of the woollen industry moved to other parts of the country. However, the twentieth century saw a gradual resurgence of Barnstaple's fortunes.

One of the best and easiest ways to look back over the last century or so of local history is to start a postcard collection. The hobby of postcard collecting began to be popular around 1903, rapidly taking hold and becoming a national obsession. A staggering six billion postcards were sent between 1902 and 1910. They were a quick, easy and readily available way of taking home a memory of a happy holiday. Originally all cards were designed with 'address this side only' and had no centre line dividing the back. Short, simple messages were written on the front, under or beside the picture. Some examples of this are seen in this book. The first split-back

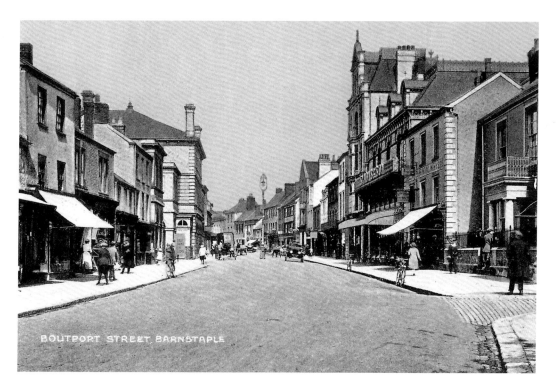

Boutport Street, showing the Queen's Theatre.

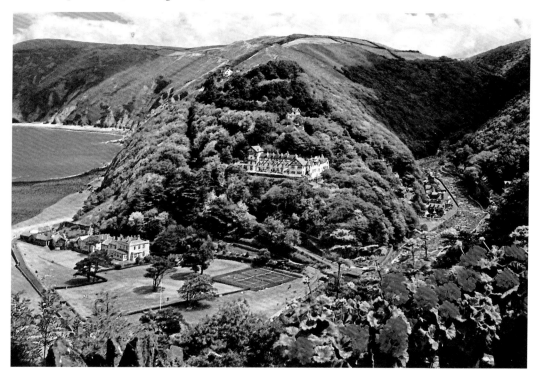

Countisbury Hill, from Lynmouth.

cards (allowing the address on the right and the message on the left) were introduced in this country on 1 January 1902. Writing a postcard to a friend or relative was seen as a casual, fun thing to do. It was not like writing a long formal letter. To send a postcard in the early twentieth century is the equivalent of sending a text message today.

However, it has to be remembered that the date they were posted is not always an accurate indication of when the picture was taken. In Barnstaple, postcards are still on sale that show the Strand before the Millennium Mosaic was laid in 2000. A nice picture will remain in use for many years, possibly decades. All dates given in the picture captions refer to the date of posting, unless otherwise stated.

In writing this book we were extremely lucky to be able to use the archives of just two people. Our grateful thanks go to Mrs Gwyneth Faye, whose superb archive of postcards were invaluable in the writing of this book. Many of the Barnstaple postcards come from her collection, and all of the surrounding area ones. Secondly, our thanks go to Mr Michael Essery: his excellent collection of Barnstaple postcards was a vital source of information and were used extensively.

SECTION 1

THE SQUARE, TAW VALE AND RIVER LIFE

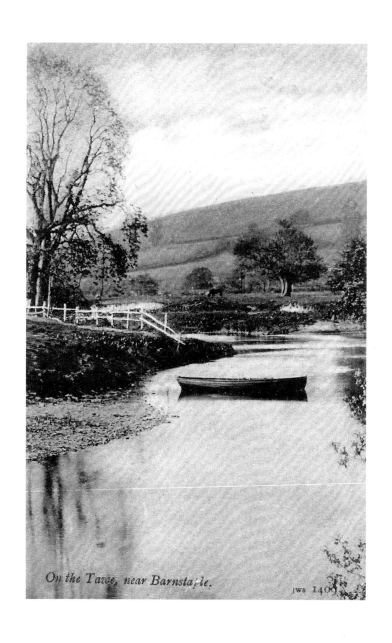

On the Taw, near Barnstaple.

jws 1400

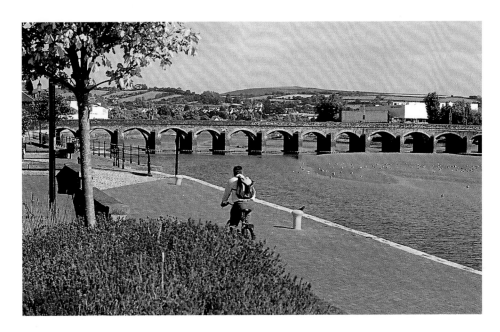

The Long Bridge from Seven Brethren Bank

The postcard below showing the bridge and an attractive view of Barnstaple from across the river was taken on Seven Brethren Bank. According to tradition, this part of the riverbank acquired its name from the seven elms that were planted to mark the burial of four brothers who all died of the plague in 1646. They are said to have been infected by some rags they fished out of the river. The trees are said to have survived into the nineteenth century. The second of these recent postcards is a view of the bridge from the downstream side, taken long after the railings visible in the older pictures had been replaced. The view looking towards Newport and beyond shows the hills that surround the town. Codden Hill, above Bishops Tawton, can be seen in the distance.

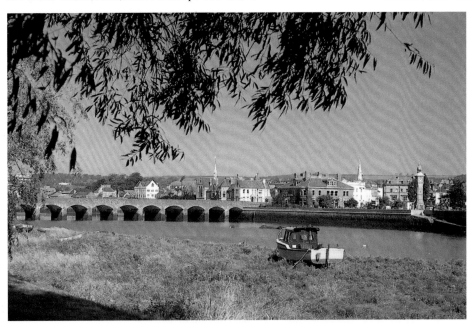

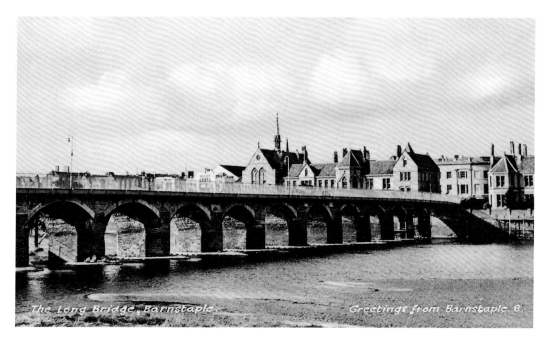

The Long Bridge, Barnstaple. Greetings from Barnstaple. 8.

The Long Bridge from the Other Side of the River

Two views of Barnstaple's Long Bridge from the other side of the river. When these photographs were taken there were still railings along the sides of the bridge. There were added in 1834 when the bridge was widened and the approaches improved. The railings were replaced at the time of the bridge's most recent widening in 1961–63. It was at that time that the Ministry of Transport took over responsibility for it. During the preceding centuries the bridge was maintained by the Bridge Trust, with the proceeds of money and property given for that purpose. It is not known precisely when it was first built, but in 1303 Alicia de Ackelane gave a rent of 3d a year to the Long Bridge. In 1545 the mayor of Barnstaple referred to the river as, 'a hugy mighty perilous and dreadful water'.

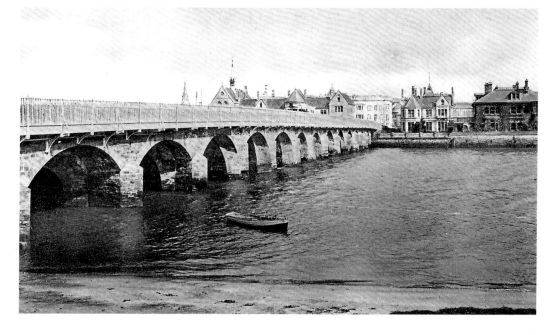

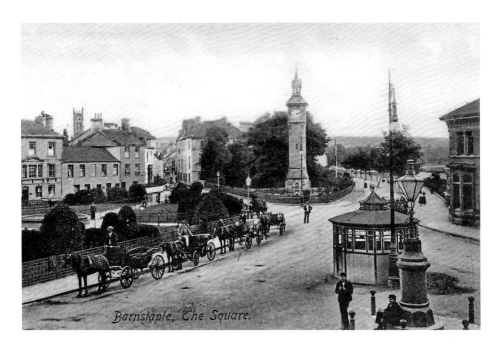

Barnstaple, The Square.

The Square
The first postcard of The Square dates from 1913 (although as is often the case, the picture was taken a good ten years earlier) and still shows the old gas lamp in use (far right). Later the lamp was removed and the plinth was used as a signpost. It is still in place along the riverside, but now stands unused, its previous use obscured. The small round building is a shelter for the cabbies, who can be seen lined up and ready for business on the left. Litchdon Street can be seen in the background, with Taw Vale curving off to the right.

The second postcard is hand tinted and was posted in July 1906. It shows The Square laid out to a slightly later and more ornate design, with flower beds and railings. The cabs have been repositioned to the front of the Albert Clock and the fountain now takes centre stage.

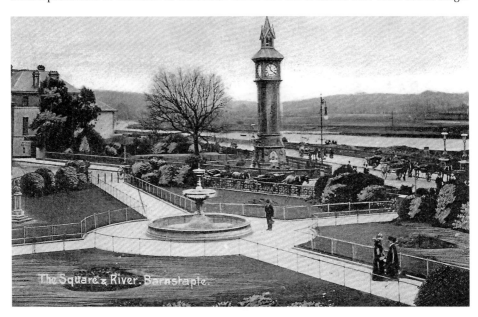

The Square & River, Barnstaple.

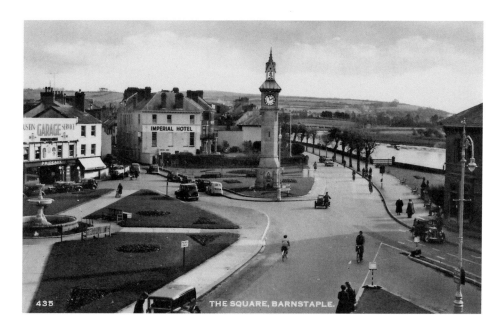

The Square

By the 1950s (the date of the first postcard) The Square had changed yet again. The railings were taken down during the war to be used in the war effort and benches are now in place where one may sit awhile and admire the view. The houses on the left, shown in the earlier views, are now shop fronts with Prideaux Garage clearly visible.

The second postcard (posted in September 1916, two months after the start of the Battle of the Somme – one of the largest and most devastating battles of the First World War) was taken from the roof of the Athenaeum. It shows the Albert Clock, erected in 1862 as the town's memorial to the late Prince Albert (husband of Queen Victoria), who had died the previous year. It was paid for by public subscription and had a grand opening ceremony.

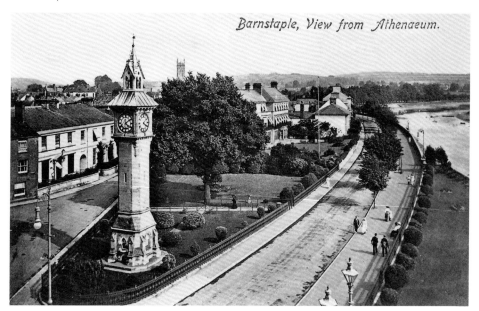

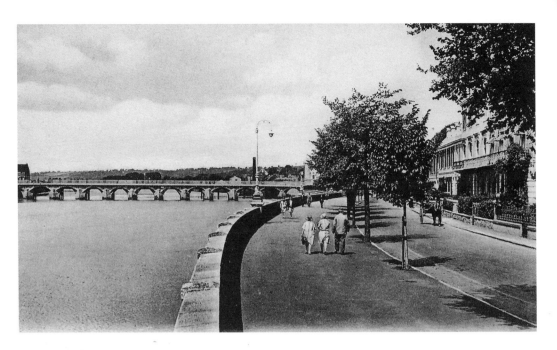

The Riverside

The first postcard shows Taw Vale (originally Taw Vale Parade), the road beside the river. This broad promenade with its attractive views of the river and bridge, was considered a great improvement to the town when it was opened in 1846. Before that date the only road out of town in this direction was Litchdon Street. The construction of Taw Vale was a considerable undertaking because the entire riverbank had to be raised. A grand terrace of houses was completed soon after the road. The second postcard shows the riverbank from South Walk (near the entrance to Rock Park) as it curves around and down to the bridge.

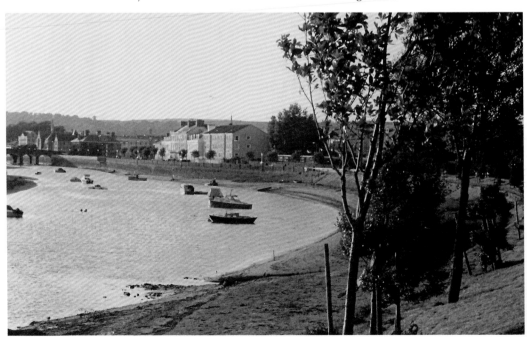

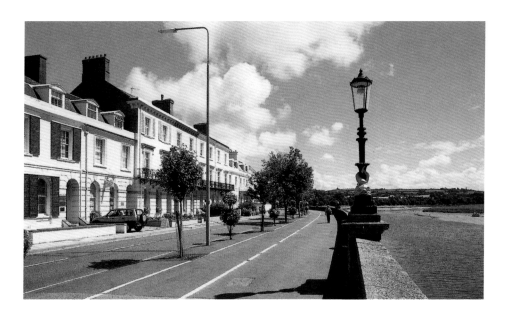

Taw Vale

Another pair of recent postcards. The broad pavement of Taw Vale now has a cycle path and there are attractive flower planters between the trees. This suggests a date in the 1990s, when for several years Barnstaple entered the Britain in Bloom competition and often won a prize. Also visible in this view, taken looking towards the park, is a modern street light, together with one of the original lights on the river wall. The original lamps were installed in 1888 with bases shaped like dolphins and made at Abraham Darby's foundry in Shropshire. The second postcard is a good view of the Imperial Hotel many years after Mr and Mrs Youings retired in 1929 and Trust Houses Ltd took over ownership. The local paper believed that their establishment of the Imperial, '... had done more than anything else to secure recognition of the claims of Barnstaple as a holiday centre.'

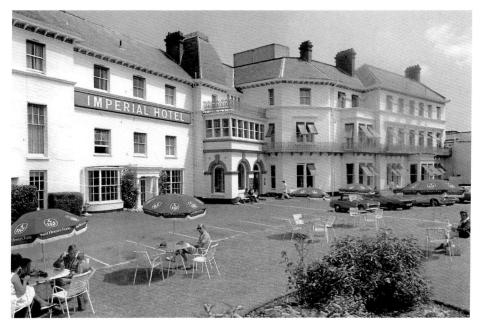

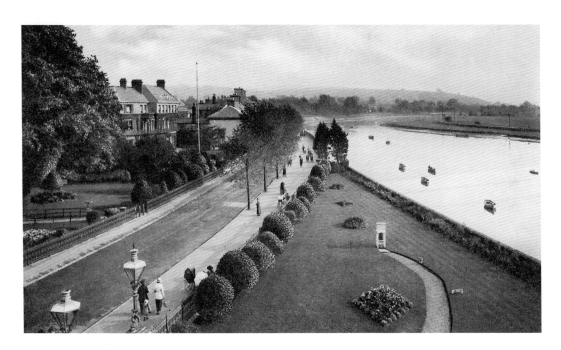

Taw Vale and the Strand

A postcard of Taw Vale, dated 1913, providing an aerial view of the road from the Square to just beyond the Imperial Hotel, with Rock Park in the distance. The Square and the Athenaeum grounds are bordered by railings, which disappeared during the Second World War. The path in the well-maintained grounds of the Athenaeum leads to the weather station where details of the weather were recorded twice daily, with monthly reports appearing in the local paper. The second postcard is undated but shows a Southern National double-decker bus. The company was established in 1929 and provided bus services in North Devon and other areas for many years. On the side is an advert for Corona soft drinks; for many years they had a factory at Newport.

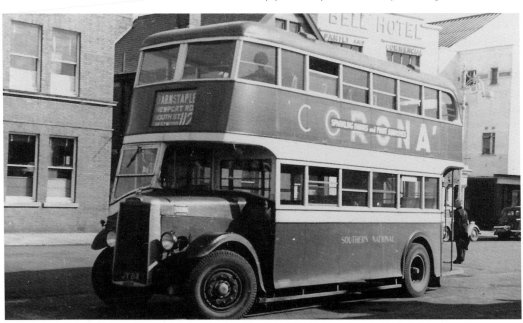

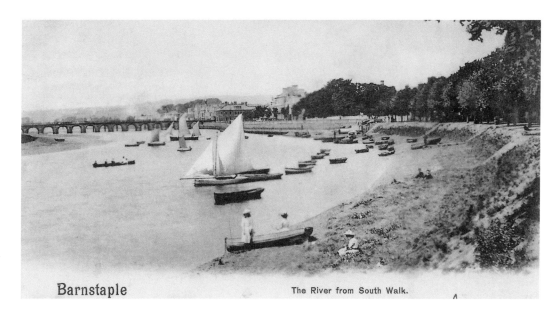

Barnstaple The River from South Walk.

Boating on the River

For many years boating was a popular leisure activity and on fine days numerous rowing boats could be seen on the river. The postcard shows the boating station on the Taw, near the entrance to the park. For many years this was run by one of Barnstaple's most well-known characters – Billy Moore. At one time he had thirty boats for hire. The boathouse was demolished after he retired; he died in 1976 at the age of ninety-three.

The postcard above shows the river from South Walk and is dated 1903. A guidebook for visitors, undated but probably from the late 1870s, recommends a river trip, '... if the Visitor has aquatic tastes as well as an appreciation of lovely river scenery of the gentler kind, he will thank us for recommending him to pull as far as New Bridge on a summer evening's tide.'

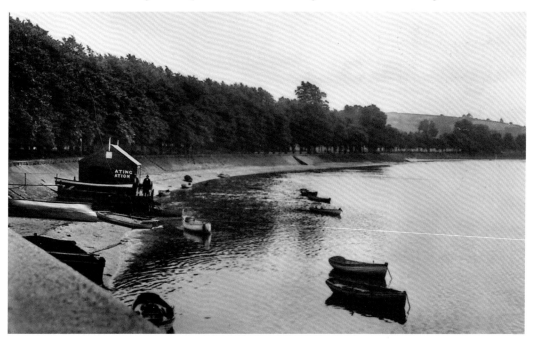

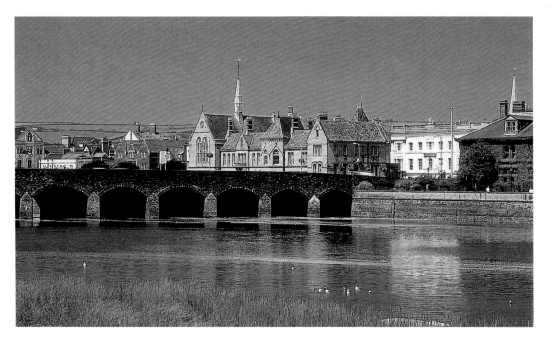

The Other Side of the River

These two postcards show the view from the other side of the river. In the colour postcard there is a good view of Bridge Chambers. This was built in 1874 by the Bridge Trust. Designed in the neo-Gothic style, it is sometimes mistaken for a church, but it was built as offices, including offices for the Bridge Trust. It also includes the Bridge Hall, a large room used for meetings and as a court room. Its architect was R. D. Gould, Barnstaple's long-serving Victorian Borough Surveyor. Thirty years earlier he had also designed Bridge Buildings for the Bridge Trust, just visible to the right of the postcard, in the contrasting neoclassical style. The black and white postcard gives an unusual view of the Albert Clock, the Square and the Imperial Hotel from the opposite riverbank.

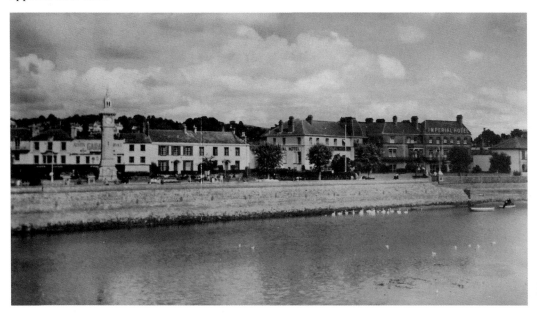

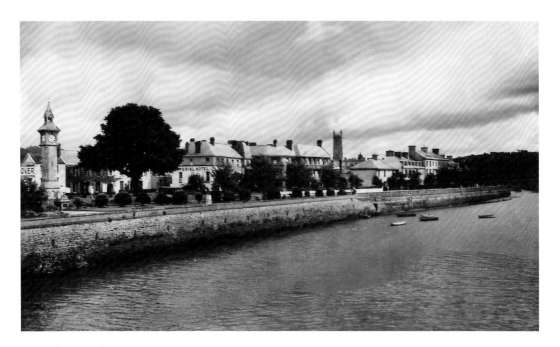

The Riverbank

The riverbank was a popular subject for postcards and two more are shown here. One is an early view of the tree-lined South Walk, adjoining Taw Vale. South Walk was begun before the development of Rock Park and in 1873 a Capt. W. Green was advertising boats for hire there. The second view is from the opposite side of the river, looking across to the Imperial Hotel with the tower of Holy Trinity Church in the background. Mr C. A. Youings purchased Litchdon House and the adjoining property in 1898 at a cost of £2,000. He spent several hundred pounds on improving the property and £1,000 on furnishings, then opened it as the Imperial Private Hotel. It was very successful in an era of increasing travel and tourism. Further additions and alterations were carried out in 1901, including the largest dining hall in the district.

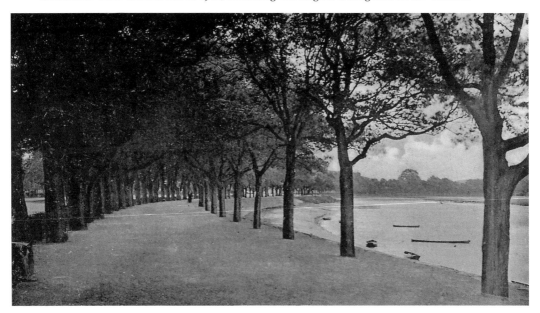

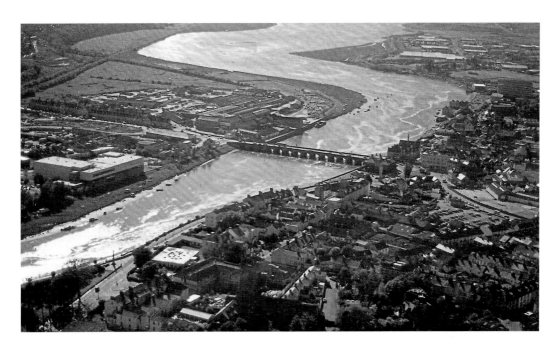

Barnstaple in More Recent Years

Here is a pair of more recent postcards. The first is an aerial view of the town from the 1990s that has been taken from an unusual angle. Just visible at the bottom left of the picture is the obelisk at the entrance to Rock Park. On the other side of the river is the leisure centre, which is also prominent in the second postcard. Looking out of scale with the older buildings, it was opened in 1975 when it replaced the swimming baths at Rock Park. It had an indoor swimming pool that held 288,000 gallons of water and provided the most popular of the twenty activities on offer. The leisure centre was built on the side of a former rubbish dump. A tennis centre has since been built nearby.

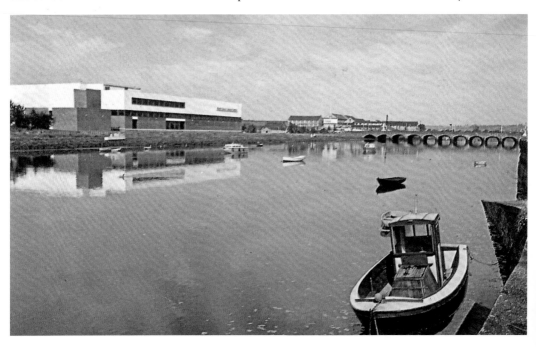

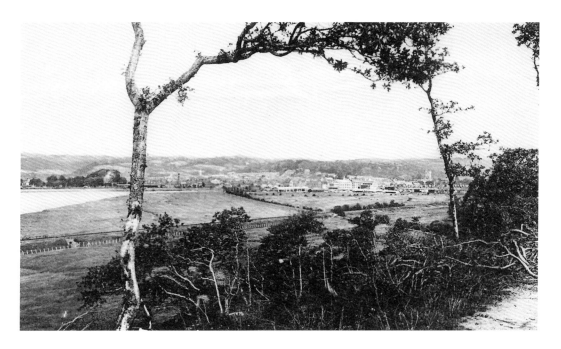

Anchor Woods

Here are two postcards taken from Anchor Woods. One gives a general view of the distant town and the second shows a closer view of the town with the focus on Shapland & Petter, one of Barnstaple's most well-known and important industries in the late nineteenth and most of the twentieth centuries. The firm of furniture makers moved to this site after a disastrous fire in 1888 at their previous premises at Rawleigh. The new factory was equipped with the most modern machinery and employed up to 350 workers at a time. Its furniture was known for the quality of its design and workmanship and they were a leading manufacturer of Arts and Crafts furniture. They also fitted out railway carriages and ocean liners. In 1924 the firm merged with the Barnstaple Cabinet Co. run by the Oliver family.

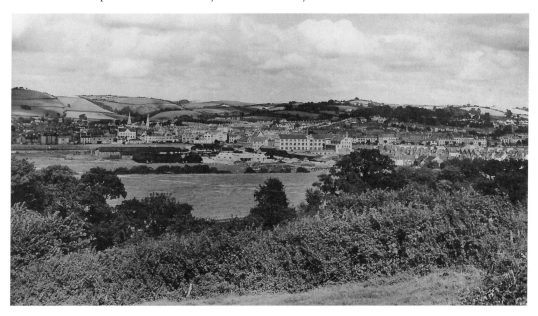

SECTION 2
ROCK PARK, LITCHDON AND BOUTPORT STREETS

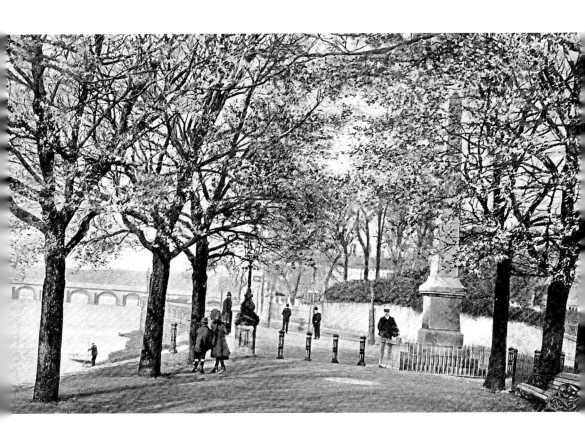

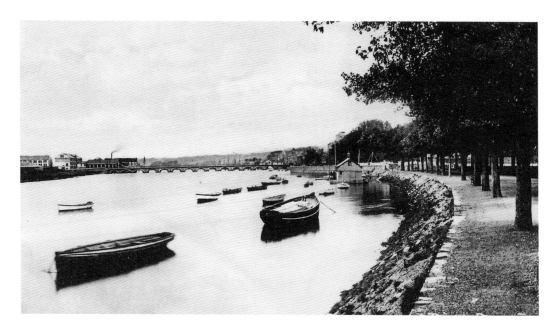

South Walk

Both of these early twentieth-century views show the tree-lined promenade known as South Walk. The construction of this promenade had begun before Rock Park was proposed. The money was raised by subscription and at a meeting in 1860, when a committee was formed to carry out the project, it was announced that £100 had been subscribed – Mayor J. R. Chanter headed the list with £50. Mr Chanter was deeply committed to providing green space at this end of town so it was called 'Chanter's Green'. Another part of South Walk was completed a few years later, but it was not finished until Rock Park was formed in 1879. Prior to this development the local paper reported that this side of the bridge was, 'almost inaccessible and quite shut out from view by limekilns and squalid buildings, as far as a shipyard which formerly existed facing the Infirmary, from which point a marsh ... occasionally overflowed by the tide, extended to Newport.'

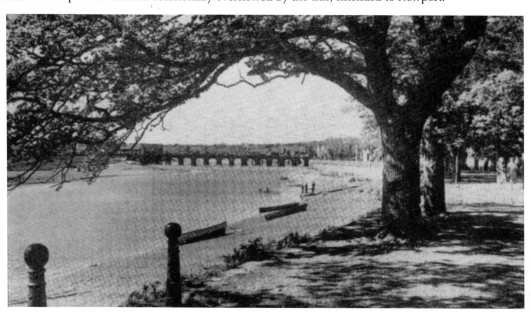

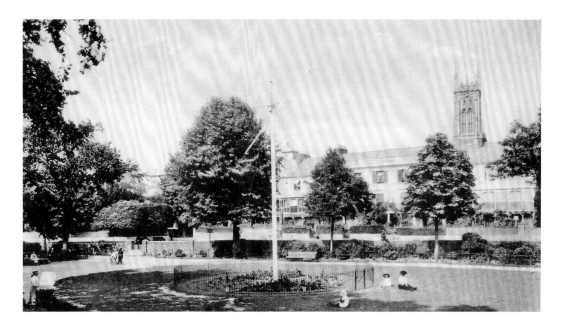

The Entrance to Rock Park

The first postcard shows a later view of the lower part of the park with the flagpole. Union Terrace and Holy Trinity church tower can be seen in the background. The second of these postcards is dated 1907 and shows the entrance to the completed Rock Park, with South Walk to the right and the adjoining park area to the left. The obelisk, which stands at the entrance to the park, was designed by R. D. Gould. The needle is Dartmoor granite, the base is red Aberdeen granite on three steps of blue penant; it measures 32 feet in height. The inscription around the base records the presentation of the park to the town by William Frederick Rock on 12 August 1879. It also bears the, perhaps optimistic, inscription, 'It is hoped that the Public will protect what is intended for public enjoyment.'

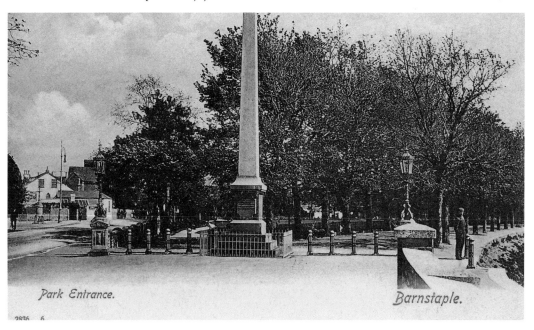

Park Entrance.

Barnstaple.

2836 6

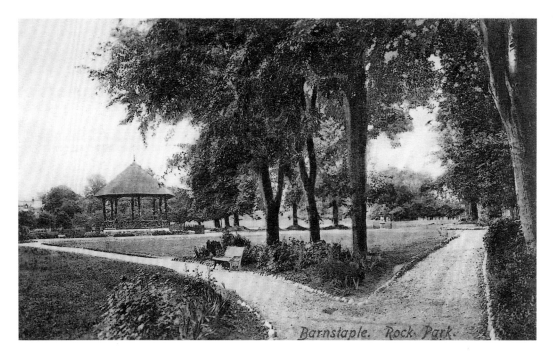

Rock Park's Bandstand

These early views show the centre of the park, featuring the bandstand, which was a significant feature for many years. It replaced the original raised area known as Rock Mount, which had been formed on an old limekiln. The Mount was surrounded by a fernery, shrubs, rustic fencing and was decorated with terracotta vases and statuary. Mr Rock had intended to provide musical entertainment for the public, but early attempts were not well attended so the idea was dropped. In 1896 the town council approved payment for the provision of a bandstand. It originally had open rustic panels, but these were replaced in 1906 by solid panels 2–3 feet in height to protect the body of the bandstand from wind and rain.

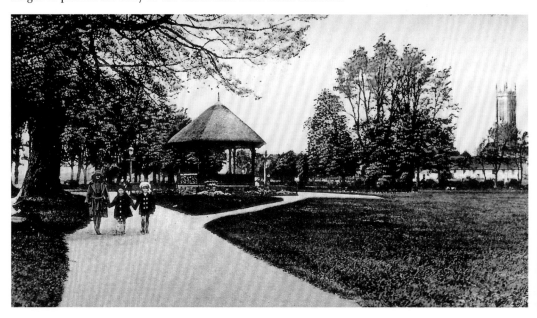

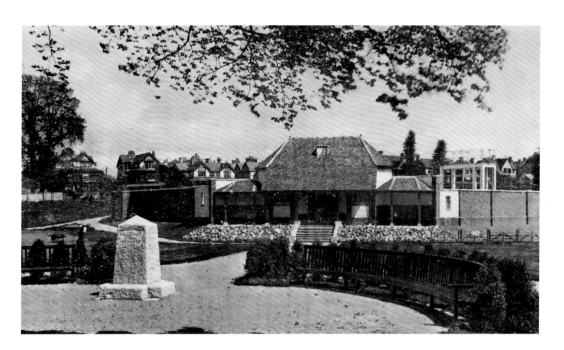

Rock Park

The second postcard provides another view of the bandstand with the tower of Holy Trinity Church in the distance. As well as being used for concerts, in later years the bandstand was the place where the Carnival Queen was crowned. In May 1944 Major H. G. Buck of the Royal Inniskilling Fusiliers gave an address about his war experiences from the bandstand. Concerts ceased during the Second World War and only resumed in July 1950. The first postcard from 1958 shows the Millenary Stone, erected in 1930, when Barnstaple celebrated 1,000 years of its history. The swimming baths were intended as a permanent reminder of the celebrations, although the provision of swimming baths was first suggested in 1876. In his opening speech the mayor said that he had learned to swim in the river, which was frequently dangerous.

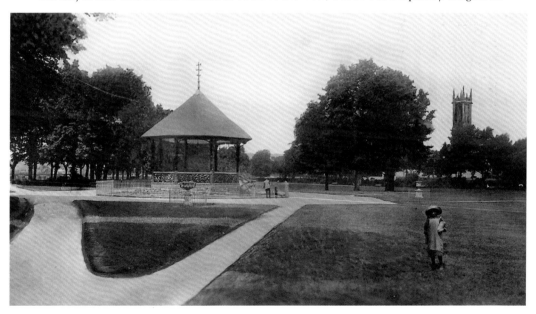

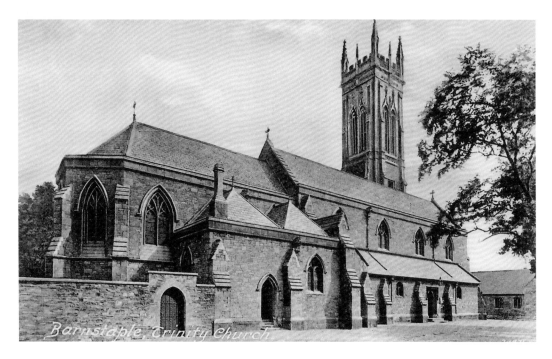

Victoria Road

This postcard shows Victoria Road in 1906. This wide, tree-lined road was only constructed in 1853. For many years it was the site of the annual cattle fair which had previously been held in Boutport Street. There was considerable opposition to the move, one objection being that there was no nearby public house for the farmers' refreshment. However, by 1863 the local paper reported that the move had been successful, stating that 'the much-decried site in Victoria Road' had been filled from end to end. Sheep were sold in a field near the road. Halfway along Victoria Road is a footpath through the graveyard to Holy Trinity Church. The church was built in 1843–45, but was discovered to be unsound so it was rebuilt, except for the tower, in 1868–70.

Barnstaple, 1900–10
Another general view of Barnstaple, with the Long Bridge and tower of Holy Trinity Church visible in the distance. The first postcard, dated 1910, is a rare view of Lovers' Grove – a tree-lined footpath that runs from the end of Ladies Mile in Rock Park. It leads to Pill Lane and the lane to Bishops Tawton. This path existed before Rock Park: a newspaper report from 1884 mentions Ladies' Mile and that its creation along the boundary of Rock Park, 'renders the ancient picturesque walk at Pill, called Lovers' Grove, accessible from the town...' Unfortunately, it does not look very picturesque in this postcard, with the bare branches of trees in winter and the pleasant view of the river out of sight.

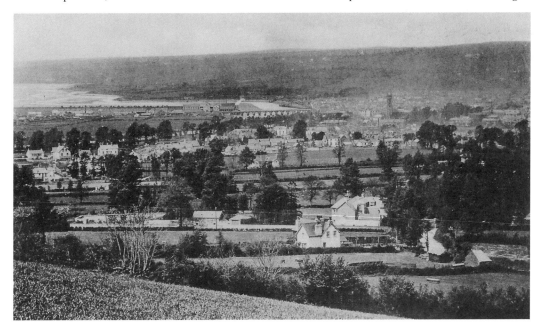

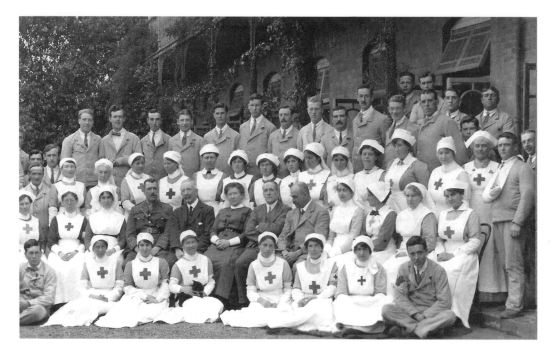

North Devon Infirmary

Two postcards relating to the North Devon Infirmary. The first shows the staff and patients in the 1920s and the second is an undated view of the building from the river. The foundation stone of the hospital was laid in 1825 by Lord Hugh Fortescue and the architect was John Shapland of Barnstaple. There were twenty beds and the first patients were admitted in 1826. A few years later a further wing was added for 'offensive or infectious patients'. Two more extensions were added in 1861 and 1881; it remained the chief hospital for the region until it was replaced by the new hospital at Pilton in 1978. To the right of the infirmary is the tower of Holy Trinity Church.

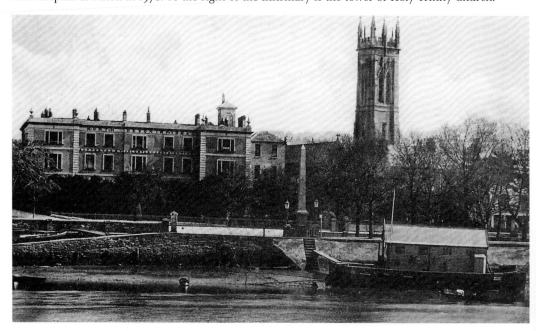

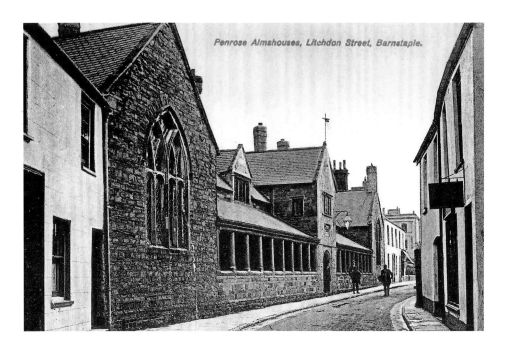

Penrose Almshouse

These two postcards provide two views of Barnstaple's most impressive almshouses, located in Litchdon Street. They were built in accordance with John Penrose's will, a merchant who died in 1624. At that time Litchdon Street was the main road to Exeter and the almshouses would have faced the river with no houses opposite. The internal view of the colonnade shows the door of the meeting room in which there are holes believed to be the result of fighting during the Civil War. There were no major battles in Barnstaple, but the town changed hands four times and there were several skirmishes. At the opposite end of the colonnade is a chapel where inhabitants of the almshouses would have been expected to attend services.

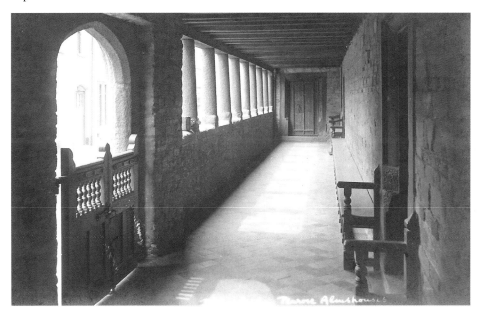

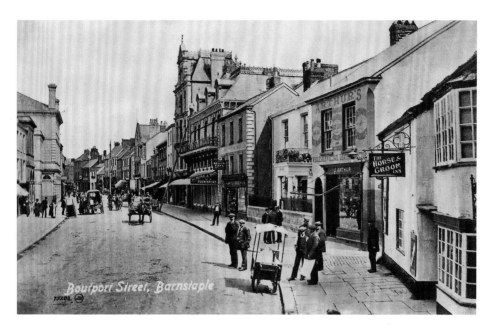

Boutport Street

These postcards show one major alteration in Boutport Street between the dates of the first and second views (1921 and 1971). In the 1960s the main Barnstaple post office moved from Cross Street to the corners of Boutport Street and Queen Street. Several buildings (including part of the Horse and Groom public house) were demolished and the narrow entrance to Queen Street, marked by the cobbles in the 1921 postcard, was widened. The front of the Queen's Theatre can be seen on the other side of the street, although it appears little changed in the later postcard, it was badly damaged by fire in 1941 but rebuilt in the same style.

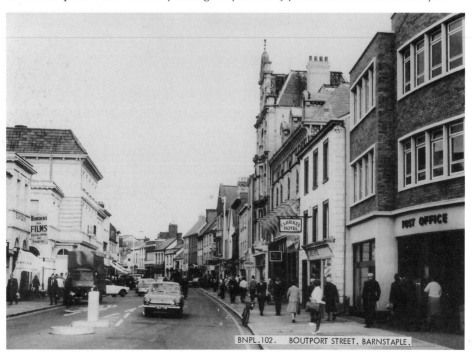

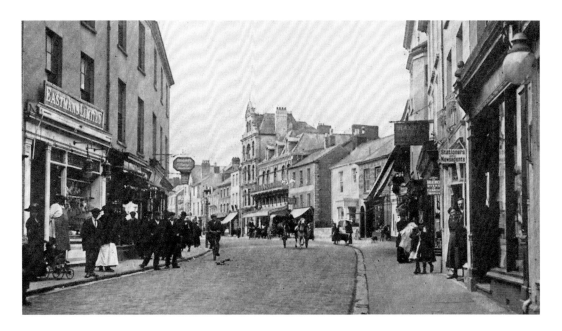

Boutport Street

Here are two more undated views of Boutport Street. Horses are still being used for transport, which was not without its dangers. In 1899 it was reported that a horse harnessed to a bread van in Taw Vale took fright at a traction engine then bolted across the Square, turned into High Street and reached Joy Street before being caught. In the same issue of the paper, it was noted that the baker, Mr Frank Raymond, had made a striking addition to the street architecture with his new building, which is just visible on the centre right of the first postcard – it is the tall building with the gable roof and finial. In the second postcard, Eastmans Ltd can be seen on the left. They were a large chain of butchers with North Devon branches at Barnstaple, Bideford and Ilfracombe. Alterations to the Barnstaple shop were completed in 1927.

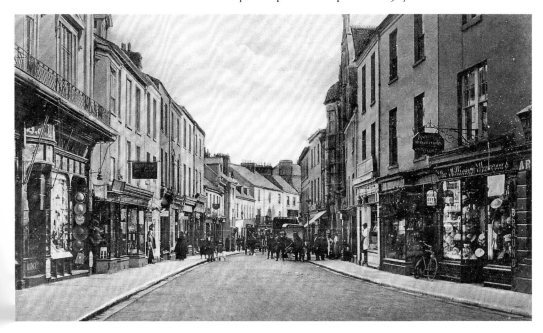

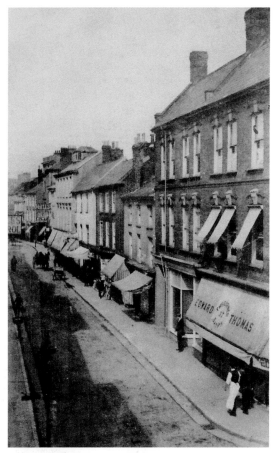

The Strand to Boutport Street

These two postcards show the roads that join the Strand with High Street, and High Street with Boutport Street. The mid-twentieth century view of Cross Street shows the long-established florist's shop of William Furse on the right. The shop moved here from the opposite side of the street on the corner of Paiges Lane. The word 'café' can just be seen on the wall of that building, as by this date it was occupied by the Swiss Café. In the earlier postcard of Joy Street the shop of Edward Thomas can be seen; it was already established by 1902 and in business for much of the twentieth century. It was reported in 1907 that Mr Thomas was the first Barnstaple tradesman to introduce a 'cash railway' – a box on wires that conveyed the customers' money to the till and returned with their change.

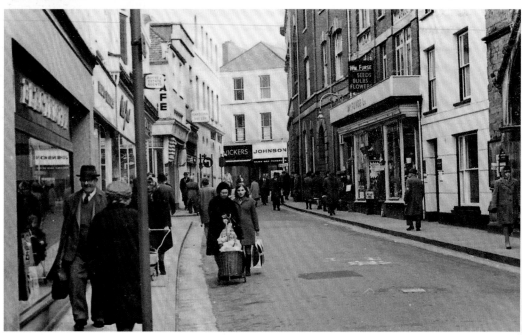

SECTION 3

HIGH STREET, ROLLE QUAY
AND CASTLE GREEN

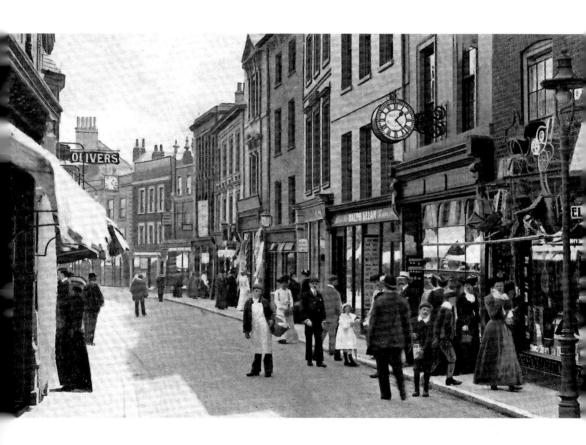

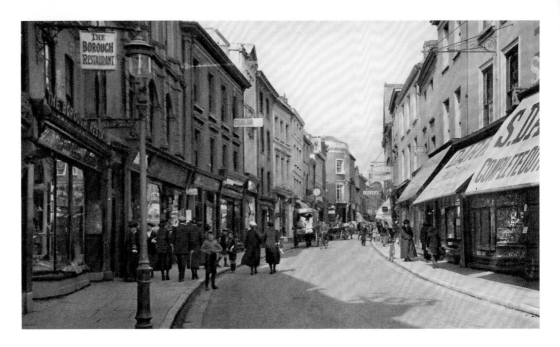

High Street

Shops change hands many times over the years, and each time this happens the new owners make various changes to the frontage. This, of course, means that over time shop fronts become almost unrecognisable from their previous incarnation, but the one thing that almost always stays the same is the upper stories. The postcards here show this clearly: it is possible to see how the upper storeys have remained unchanged over time, while the shop fronts below have been modernised and updated. The clock on the right belonged to a jeweller called Fox. He was one of three jewellers in the High Street at this time, the others being Sly & Co. and A. E. Dark of No. 14 High Street, consequently known as the Dark Sly Fox.

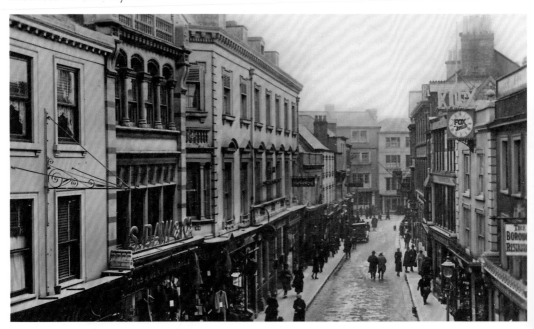

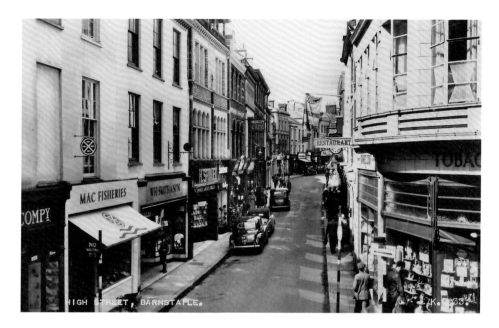

High Street

In the postcard above Mac Fisheries can clearly be seen. Started by William Hesketh Lever just after the First World War as a way to resurrect the fishing industry on the Isle of Lewis (which he owned), Mac Fisheries became a chain of fish shops throughout the whole of Britain. He bought shops in every town and city as they became available. The Barnstaple shop closed in 1976 with the entire firm closing from 1979.

Before WH Smith took over the High Street address, seen in the first postcard, it was, somewhat appropriately, the home of A. E. Barnes Library.

The postcard below shows the High Street in the early 1950s. There are several men in military uniforms and the man in the white coat, on the far right, is sporting a very up-to-date haircut.

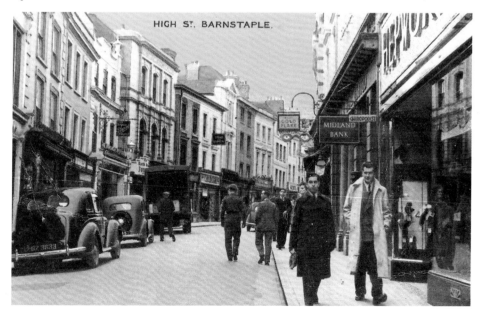

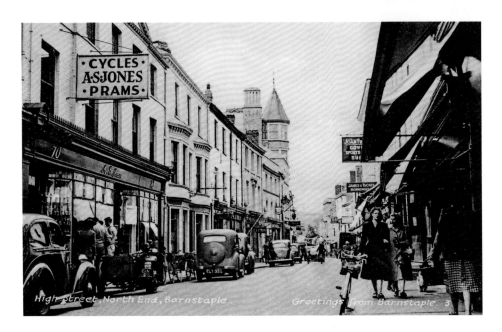

High Street

The first postcard, dated 1952, shows the north end of the High Street, with the tall Victoria Hotel visible further down. Opened in 1888 as the Victoria Temperance Hotel, it later housed council offices and is still called Victoria Chambers. The entrance to Gammon Lane is next to it.

In the foreground of the picture there is a shop sign for A. S. Jones Cycles and Prams. Archibald S. Jones was also listed in the 1941 Kelly's Directory as being a motorcycle agent at No. 70 High Street, presumably the same business.

In the second postcard, among the shop signs clearly visible and protruding into the street, is that for the *North Devon Herald*. First published in 1870, it was amalgamated with the *North Devon Journal* in 1941. The paper was first published in 1824 and was known as the *North Devon Journal Herald* until 1986

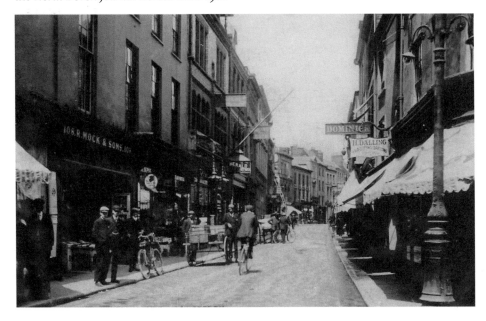

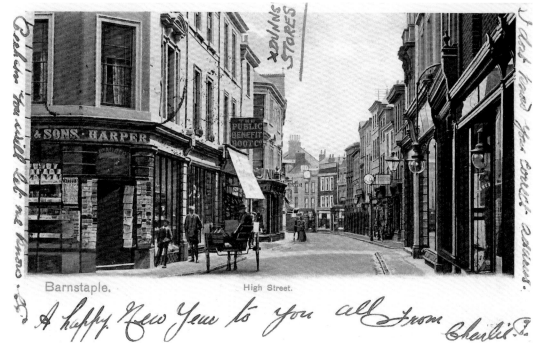

High Street

Both of these postcards show the well-known Barnstaple booksellers and stationers run by the Harper family. Robert Harper died in 1898 and on the day of his funeral a football match between Bristol and Barnstaple was cancelled, as was a concert at the music hall. Robert's wife Eliza, mother of Sydney Harper who ran the shop for many years, died in 1915 at the age of ninety-three. In 1907 they advertised that they stocked, '2,000 6d Novels all the Latest Out.' In 1910, Sydney Harper wrote a popular history of the town titled *History of Barnstaple for Boys and Girls Past and Present*. As well as books, the shop sold stationery, including a large range of Christmas cards and leather goods such as purses, handbags and writing-cases.

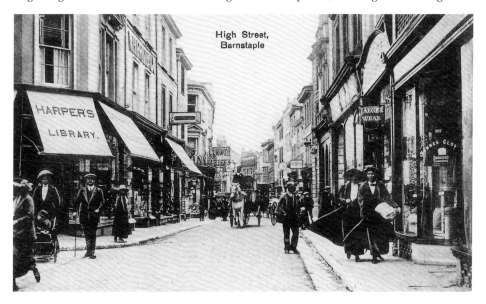

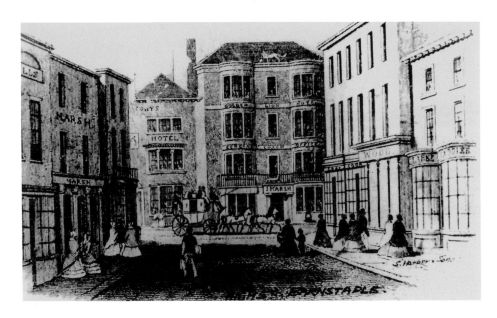

'The Hotel End of the Street'

This area was called 'the hotel end of the street' as it faced the two long established coaching inns - the Fortescue (later the Royal and Fortescue) and the Golden Lion, as shown in this early postcard. For almost sixty years of the nineteenth century the proprietress of the Golden Lion was Mrs Marsh, who died in 1894. The other postcard shows the view in the opposite direction, looking at this end of High Street. Prominent in the photo is A. E. Barnes' Library, previously Marks Bros. It was a bookseller and stationers and in December 1900 a report in the local paper noted that the shop stocked a large variety of fountain pens and an immense variety of photo frames in various sizes. Tupper & Sons at No. 109 High Street were drapers. The shop was taken over by H. F. Hagley in 1905.

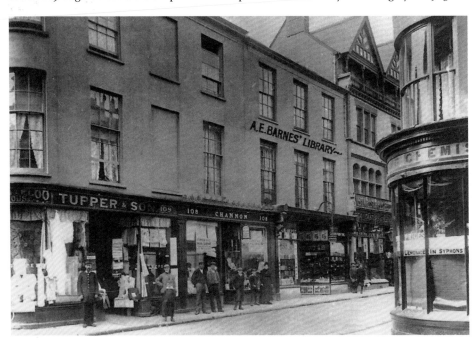

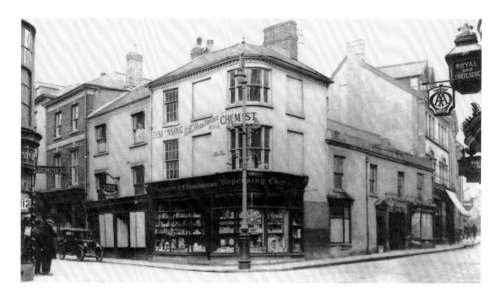

The High Street Corner Shop

These postcards, probably dating from the mid-1920s, show the corner building which was later rebuilt by the tobacconist H. E. Youings to become the current shop that remains in their family. At the time of the photograph it was occupied by E. W. Proudman's pharmacy. Mr Proudman had started in business in Australia but came to Barnstaple in 1906, retiring in 1938. The shop next door, Dallings, was taken over by Youings who continued to run the hairdressing business. The Misses Dominick had a confectionery shop and in 1892 were advertising ices that could be supplied for wedding breakfasts or other parties. On the extreme left of the postcard the other corner shop can just be seen, which became Briggs & Co.'s shoe shop in 1926 and continued there for much of the twentieth century.

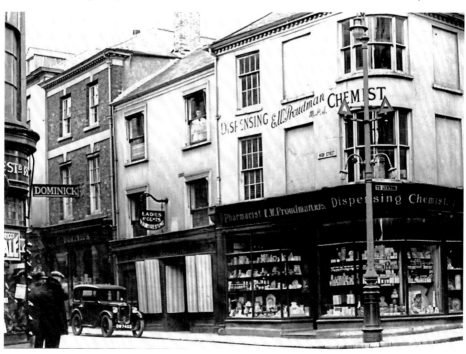

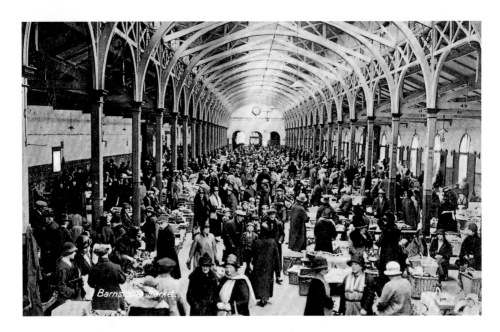

Pannier Market

The Pannier Market was designed by the borough surveyor R. D. Gould and erected in 1855. First recommended as early as 1811, previously the market was held along the High Street. The scheme involved the demolition of a large number of houses, a slaughter house and the corn market. Occupying a space equal in area to about 45,000 feet, the plans were considered far too large and there was considerable controversy at the time. The first postcard shows a view looking towards the theatre end of the market, with the more modern scene showing the view towards the Guildhall.

The Pannier Market has always been a busy hub of the town, with a normal food market on Tuesday, Friday and Saturday, an antique market on a Wednesday and a craft market on Thursday.

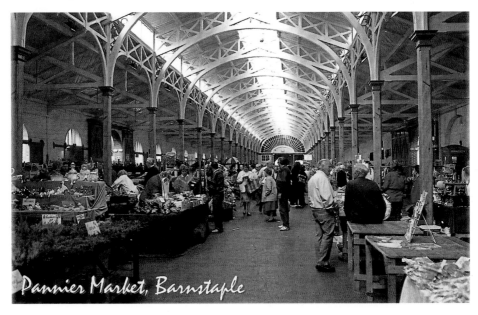

Pannier Market, Barnstaple

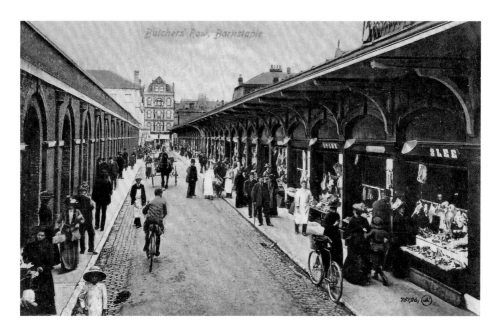

Butcher's Row

Butcher's Row was built at the same time as the Pannier Market in 1855, and was part of the town improvement designs by R. D. Gould. The road was cut through between the High Street and Boutport Street to make way for it. Comprising of thirty-three shops, each with a frontage of 10 foot 10 inches and pilasters of Bath stone with wrought iron brackets supporting the roof overhang. There were originally stone arches at the Boutport Street end, but these were damaged by lorries so frequently that the council finally decided to demolish them in the 1960s. The open-fronted shops were intended exclusively as a meat market and remained so until the Second World War when meat became in short supply, prompting the council to allow some vegetable and fish shops to be based there, as well as the traditional butcher's shop.

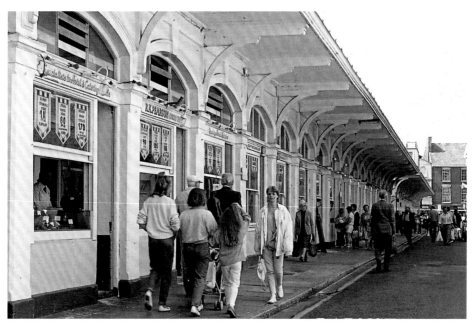

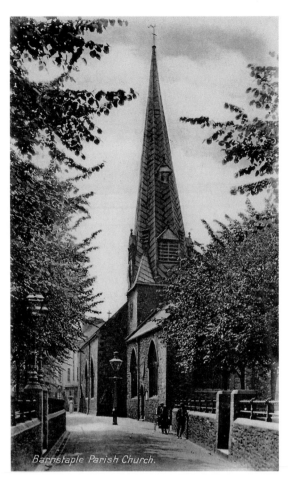

Barnstaple Parish Church.

Parish Church

These two postcards feature the parish church, situated in the centre of Barnstaple between High Street and Boutport Street. The date of the first church on this site is unknown, but it was reconsecrated in 1318 and some stones in the building are believed to be about 100 years older. Major restoration work took place in the second half of the nineteenth century. The spire was added in the 1380s and has been repaired several times since then. Its twisted appearance is probably the result of centuries of sun and rain on the timber and lead of its construction, although it was struck by lightning in 1810. The church contains several monuments to Barnstaple's wealthy merchants, including Thomas Howard and Richard Beaple. The celebrated organ was installed in 1754 and completely restored in the 1990s. On the right of the 1904 postcard the fourteenth century St Anne's Chapel can be seen, now an arts and community centre.

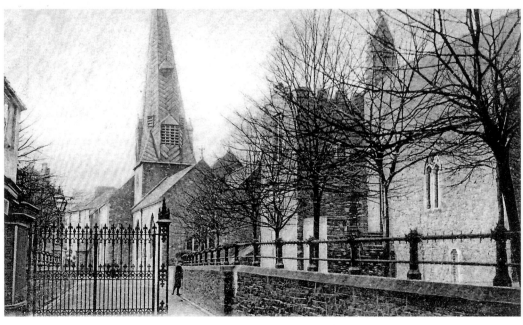

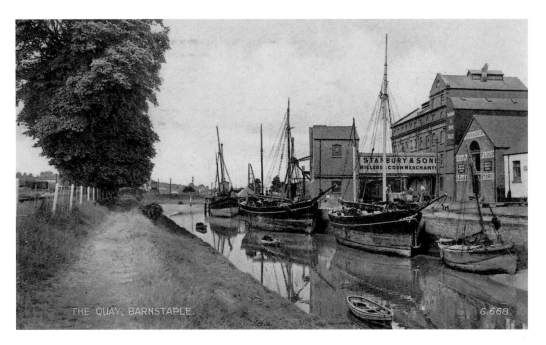

The Quay, Barnstaple.

Rolle Quay

Rolle Quay was a thriving working dock area that had boats coming and going with rapid frequency. They would be loaded with cargoes of coal, grain, slag and agricultural produce and return with fertiliser or coal. Part of the railway line came along the quayside, allowing for the easy loading and unloading of boats. The first postcard shows the Stanbury & Son Victoria Flour Mills, which stood at the end of the quay nearest the mouth of the river. It was built in 1898 by Richard Stanbury, the owner of water-driven flour mills at Knowle and Heddon Mill. The Kathleen and May schooner, registered at Bideford and on display there for several years, was one of Stanbury's boats. Upon his death the business was sold to J. Arthur Rank, which later became Rank Hovis McDougall. Mr Rank later went on to found the Rank Film Organisation.

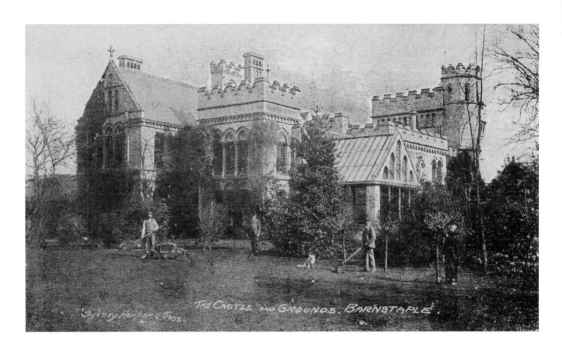

Castle House

This postcard from 1912 shows the Castle House, built in the grounds around the Castle Mound. The earliest reference to a castle on top of the mound is in the early 1100s. By the mid-sixteenth century it was in ruins. For centuries the area was a public space used for sport, military musters and celebrations. It became private ground in the eighteenth century and the postcard shows the Victorian house in which the last private occupant, Mr W. F. Hiern, lived. He was a famous botanist and erected large greenhouses against the walls of the house. After his death Barnstaple Borough Council purchased the house for use as offices and it remained as such until the Civic Centre was constructed. It was demolished in 1976.

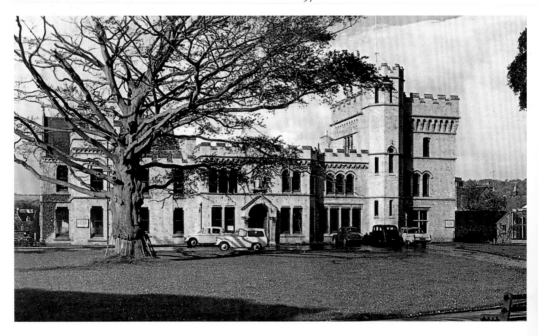

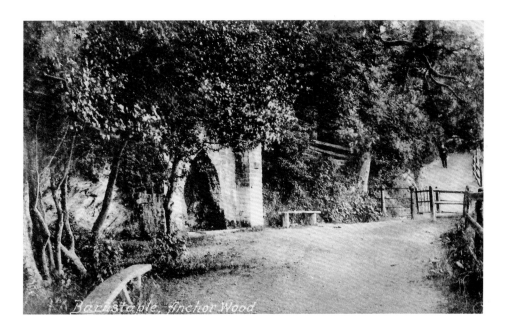

The Dripping Well at Anchor Wood

These two pictures from 1918 show the Dripping Well at Anchor Wood on the opposite side of the river to the town. A newspaper report of 1867 referred to, 'The "Dripping Well" which is situated in a lovely dell close by the entrance to Anchor Wood. The waters of this well have been analysed by Professor Herapath and found to possess great medicinal virtues.' Apparently the waters were found to contain a quantity of alkaline salts which it was believed would help, '... where a constitutional disposition exists to produce in the various secretions of the body a decidedly acid reaction...' The waters of the well were also thought to help weak eyes. The riverbank footpath and well plateau had been improved earlier in the 1860s with access via a rustic gate, which would swing close to keep the cattle on the marsh from straying into the area. Since that time there have been several further changes.

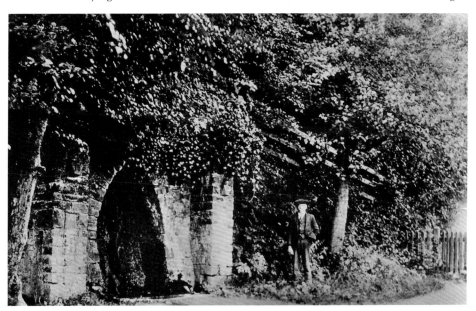

SECTION 4
THE STRAND, PILTON AND LANDKEY

Dear
A very pressing engagement will keep
me in Barnstaple for some time.

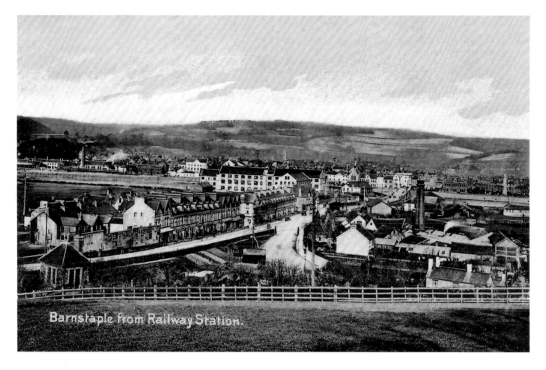

Barnstaple from Railway Station.

Victoria Road Station

The hand-tinted view of the town, taken from the railway station, clearly shows the newly built Sticklepath Terrace on the left. This area had seen a great deal of development with the coming of the railway in 1854 and the changes that brought with it. Houses and factories sprung up and the station quickly expanded. Earlier views show this site as pleasant tree-filled countryside.

The Victoria Road railway station (one of Barnstaple's four stations over the years) was the western terminus of the Devon and Somerset railway. It took passengers to Taunton from 1871 until 1960, then until it closed in 1970 it was used for freight. The goods shed is still there and has now been converted into Grosvenor Church.

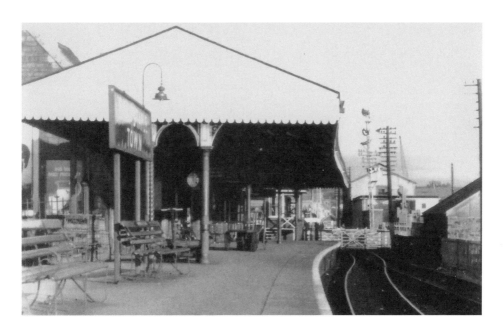

Town Station

Town Station was built in 1898 to replace the old Quay Station, which by that time had become too small. It was a narrow gauge line that ran from Barnstaple to Ilfracombe. After closing in 1970, while the track has long gone, the station building is still there and currently being used as a school.

After the Second World War, Southern Railway wanted to increase the use of the railways for leisure activities and created the Devon Belle luxury express passenger service. Starting in June 1947, the Pullman coaches with an observation car attached to the rear became hugely popular. The observation car consisted of a coach with large glass windows all the way around and would give superb views of the surrounding countryside from Ilfracombe to Barnstaple. The coloured postcard shows the service crossing the metal railway bridge, taking the line across the river and on to Town Station. It finally ended in 1954.

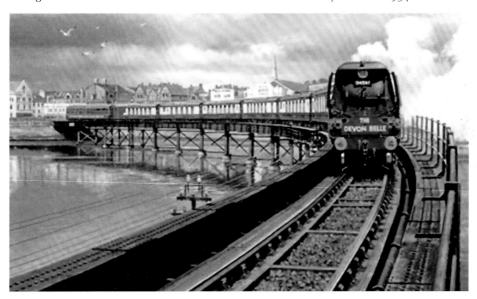

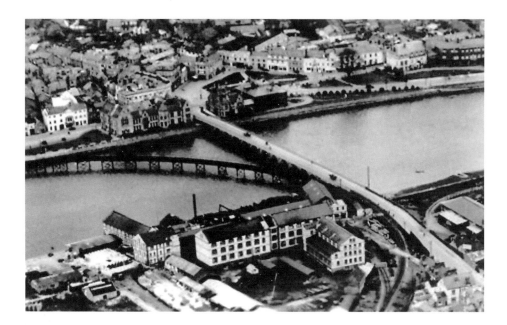

Aerial Views

Both postcards show aerial views of the town, with the curved iron railway bridge clearly visible. It was constructed to allow trains to cross the River Taw, 213 yards long and curved through ninety degrees. It consists of fifteen pairs of main girders, each one 40 foot in length, with the weight of the bridge resting on wrought-iron piers that are sunken into the riverbed and filled with concrete. It was taken down in 1977.

In the first postcard the Shapland & Petter building is clearly visible. After it was established in the 1850s, the firm of fine furniture makers soon gained an excellent reputation with showrooms in Berners Street, London. The company survived in various forms until recently, but the building currently still stands. The Museum of Barnstaple and North Devon has a fine collection of their work and several pieces are still in place in Barnstaple Guildhall.

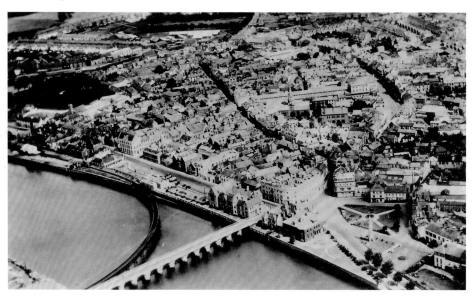

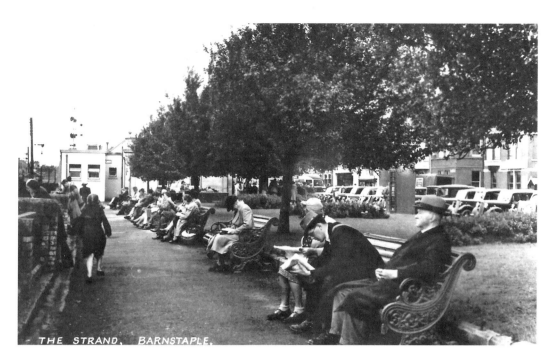

THE STRAND, BARNSTAPLE.

The Strand

The Strand area of Barnstaple has changed many times over the years, but probably the biggest transformation happened when the railway arrived in 1854. The first postcard shows the riverside when the railway line was still there. The Quay Station had been demolished in 1922 and was replaced with the bus station, but the signals for Town Station can be seen on the left.

The view taken from the Long Bridge, photographed around the same time, gives an excellent panorama of the buildings along The Strand. Clearly visible is the Bell Hotel, with its modern façade; it was originally known as The Bell Commercial Hotel. The Regal Cinema, dating from 1937, stands on the site of the old Angel Hotel and is now used as a nightclub. In the top left-hand corner the second Congregational Church Schoolrooms, built by R. D. Gould in 1894 can be seen.

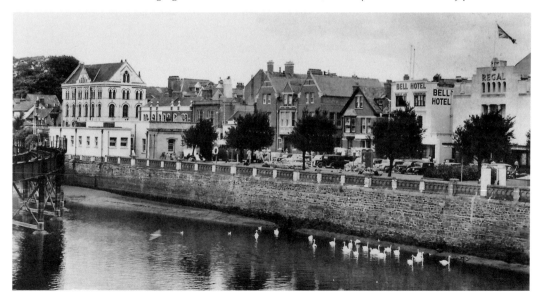

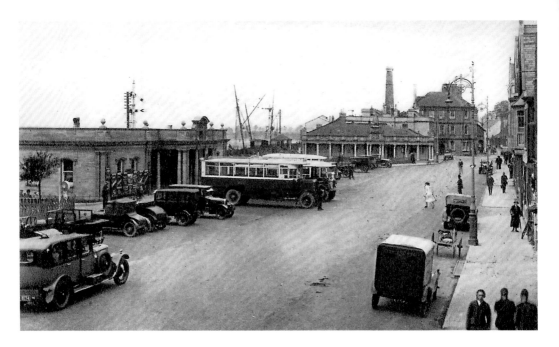

The Strand

The first of the postcards shows the bus station shortly after it was built in 1922, when major alterations took place to the Strand. Replacing the old Quay Railway Station, it stayed in use until the new bus station was relocated to Belle Meadow in 2000. The Strand is now pedestrianised and the building is in use as a café.

The second postcard shows the fish market along the Strand. Dating from 1873, it replaced an earlier Shambles that was demolished when the Quay area was widened with the arrival of the railway. It was never a success and finally closed in 1896. By the time of the photograph, the building had become almost derelict with the ornate turret it originally had having long been removed for safety. The fountain and sun dial (presented to the town by Barnstaple Girls Grammar School) is now on this site.

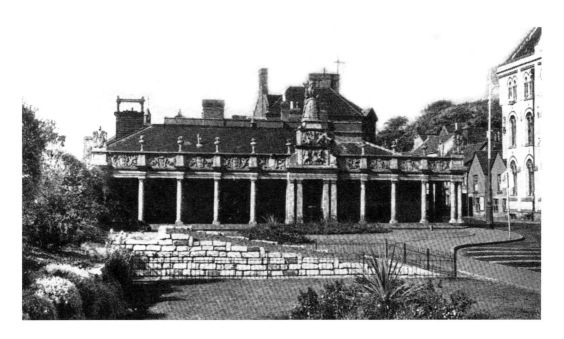

Queen Anne's Walk

A merchant's walk has been on this site since the seventeenth century, but the present structure dates from 1709. It was paid for by the merchants who used it, and their family crests can be seen carved along the top. The statue of Queen Anne was added by Robert Rolle in honour of the reigning monarch of the time. It is possible that the columns may come from an earlier structure. The Tome Stone, which can be seen in both pictures, was placed on the Quay in 1633 to replace an earlier stone.

It is hard to imagine now that this area was once a busy quay with ships coming in, goods being bought and sold, troops embarking for foreign wars and people sailing to new lives. The building attached to the back of the colonnade was built in 1859 as a public bath and wash-house, but closed after only ten years.

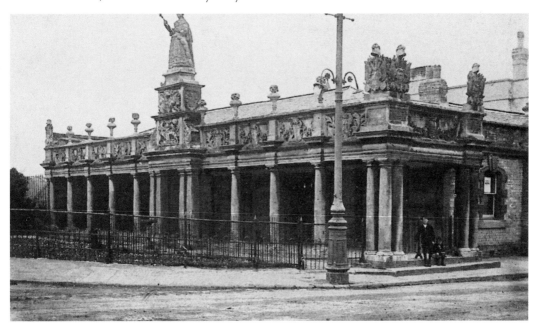

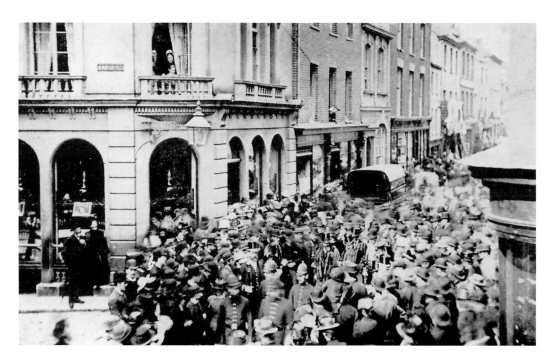

Barnstaple Fair

These two postcards, from 1886 and around 1904, show the scene at the proclamation of Barnstaple's ancient fair. They were both taken at the end of Cross Street (the site of the old West Gate), opposite Queen Anne's Walk. The proclamation is still made after the official opening of the fair at the Guildhall, although it no longer attracts such a large crowd. A report of the 1886 fair noted that 'the latest catchpenny' at the Pleasure Fair, which followed the Horse and Cattle Fair, was instantaneous photography 'done while you wait'. This would have been a great novelty at that date, although according to the report the results were less than flattering to the sitters. For many years the Pleasure Fair was held in the square, but by 1886 it was in Castle Street.

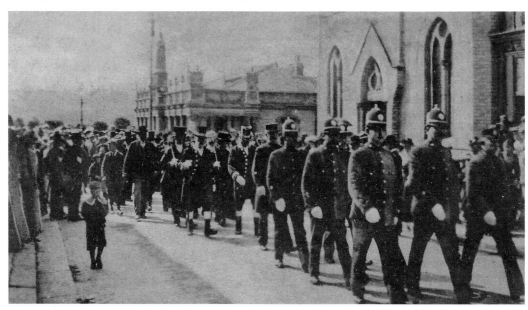

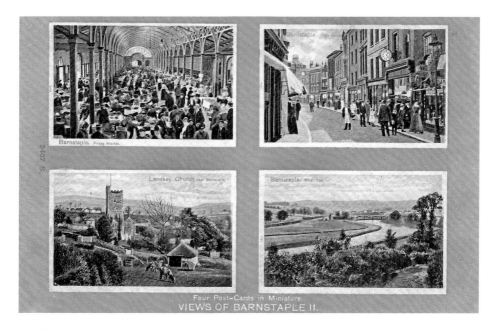

Four Post-Cards in Miniature
VIEWS OF BARNSTAPLE II.

Landkey

The first of these postcards is undated, but is probably from the early twentieth century. It gives two views of the town: Pannier Market and High Street, and a view from the south of the river – flowing towards the town with the railway bridge just visible in the distance. That bridge is still there today, but it is now used by pedestrians and cyclists. The third view is of Landkey, like the second postcard that is dated 1908. Landkey is a village a few miles from Barnstaple. The church stands above the village and is a late fifteenth-century building, although the chancel was rebuilt in 1870. The place name indicates a very early origin for the village since it refers to a Celtic saint – the church of St Kea – a name also found in Brittany and Cornwall. The church is now dedicated to St Paul, but the name is a reminder of the age of many villages.

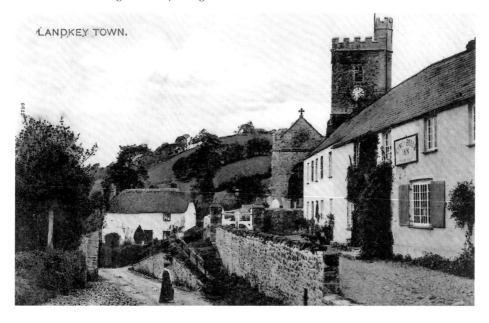

LANDKEY TOWN.

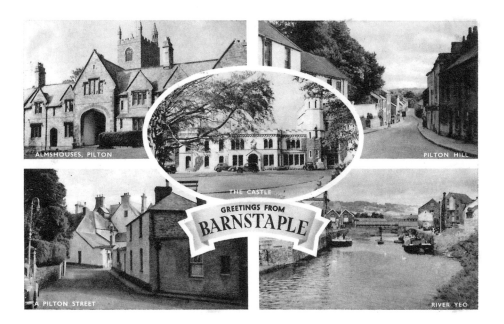

Pilton

Above is another compilation postcard, this one is dated 1956 and has five miniature views. The Castle House is in the centre, surrounded by three scenes of Pilton and one of the River Yeo. The boundary between Barnstaple and Pilton runs along the middle of the riverbed, or in some places on land where the river used to flow before alterations were made. In the past the low-lying area between the two settlements was very marshy, as it was between Barnstaple and Newport (for centuries both were separate communities), only becoming part of their larger neighbour in the 1830s. Pilton may be the older settlement as it is possible that Alfred's burh was on the high ground of Pilton originally, before Barnstaple became the main town. The almshouses seen in the top-right view date from a rebuilding of 1849, although they are of Tudor style and appear older. The image below is an older postcard of Pilton Street.

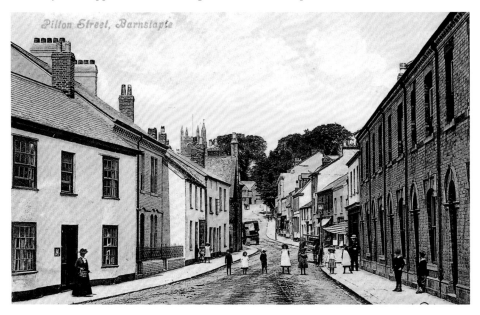

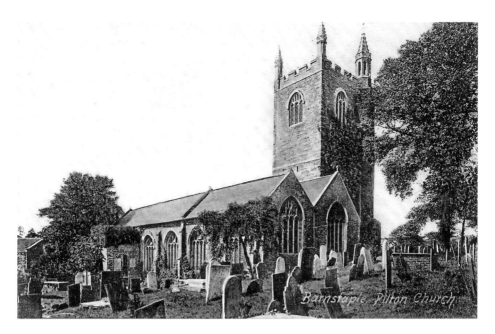

Pilton Church

Another early view of Pilton Street, together with a postcard of the church at the top of the street. There was a small priory at Pilton, founded in the twelfth century on the north side of the church, which was originally the priory church. By the time the priory was dissolved in 1536 there were only three inhabitants. While the earliest parts of the building date from the thirteenth century, there were many additions and alterations in later years. The interior contains several monuments to the Chichester family, who lived at Raleigh until the late seventeenth century. The North Devon District Hospital now occupies the site of their estate. Raleigh was one of the four manors named in the Domesday Book that later became the parish of Pilton. The church tower was rebuilt in 1696, fifty years after it had been partly destroyed during the Civil War.

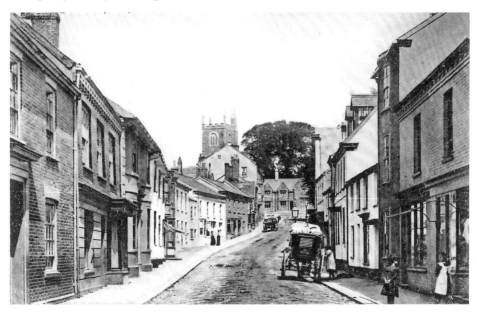

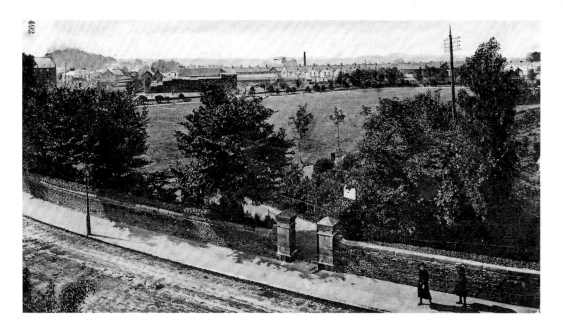

Pilton

The postcard of Pilton Street (below) gives a good impression of the range of properties, in terms of age and style, in the street leading up to the church. The building to the left of the picture, with its side wall to the road, became the parish workhouse in 1740 but was later replaced by the Barnstaple Union workhouse in 1837. In 1860 it was rebuilt as almshouses. Many properties were rebuilt in the nineteenth century, but sometimes older parts of them have survived behind the street frontages.

Pilton priory owned several of the properties in Pilton Street, with the Dissolution of the Monasteries they were acquired by George Rolle, who retained some of the larger properties at the top of the hill and sold the smaller tenements to the occupiers. Pilton Park, seen in the above postcard, was created on marshland in 1898.

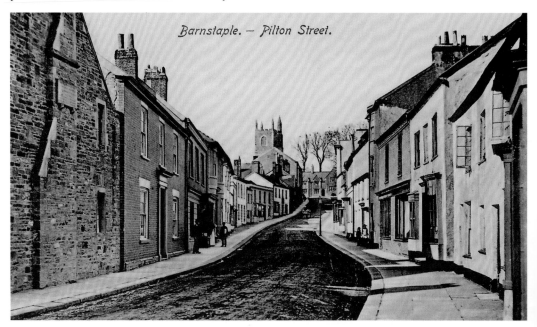

Barnstaple. — Pilton Street.

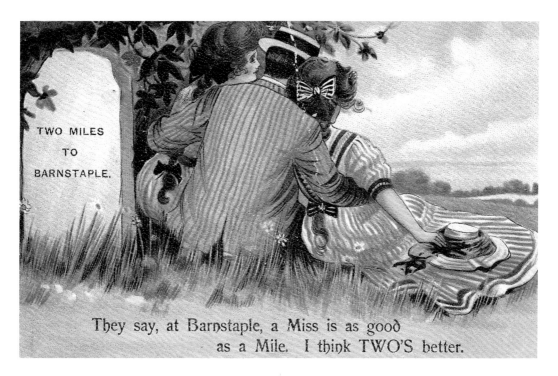

TWO MILES
TO
BARNSTAPLE.

They say, at Barnstaple, a Miss is as good as a Mile. I think TWO'S better.

Novelty Postcards

As well as the pretty scenes of various local views that graced the front of popular postcards, in the late Edwardian period a fashion began for sending cartoon postcards. A forerunner of the seaside comic postcards, they would be in the form of humorous pictures with the name of the town or village.

The first postcard shows a man in his summer clothes with his arms around two fashionable local beauties. The caption reads 'They say at Barnstaple a Miss is as good as a mile. I think TWO'S better.' This would have been considered quite risqué at the time. The second postcard has a more to the point message, with the caption 'Come to Barnstaple. By gum! It's all right.'

COME TO

BARNSTAPLE

FOR A HOLIDAY.

By GUM !

IT'S ALL RIGHT.

279 L

SECTION 5

TOWNS AND VILLAGES TO THE NORTH OF BARNSTAPLE

ON THE LYN, DEVON

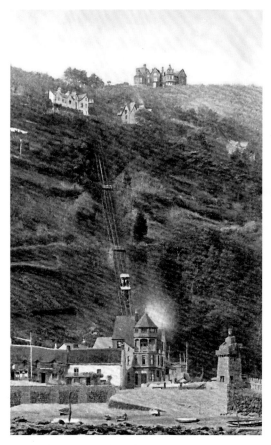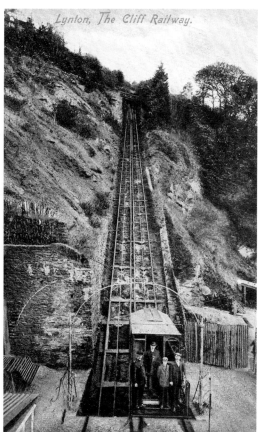

The Cliff Railway at Lynton

Travelling between the twin towns of Lynton and Lynmouth was a time consuming process in the nineteenth century. Foodstuffs and other essential items would arrive at Lynmouth by boat and then have to be carried by packhorses up the steep hill to Lynton. The first proposals to build some sort of rail-based system were made in 1881, but it would be another nine years before the cliff railway opened.

The water-powered railway was designed by George Marks and is comprised of two cars that can each hold up to forty people. Each car has a 700 gallon water tank underneath that releases the water, allowing one car to rise as the other lowers. The rails rise to 500 feet and are 862 feet long.

The second postcard shows a group of people, including one of the drivers, posed at the bottom.

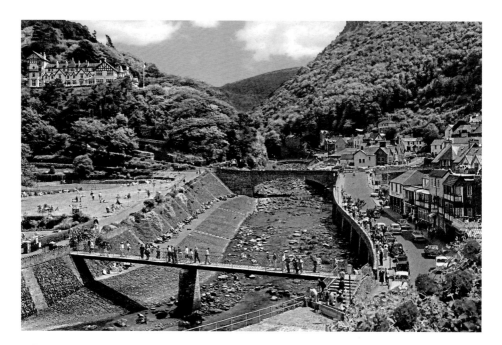

Lynmouth

The first postcard shows the footbridge over the River Lyn, with a bus beginning its ascent up Countisbury Hill. The Tors Hotel is visible in the background.

The view of Lynmouth in the second postcard (dated 1919) is almost unchanged. The roofs of the first two buildings are still thatched and clearly recognisable. The house on the near left is now the Rising Sun Hotel and restaurant.

The area around the twin towns of Lynton and Lynmouth has been called the Switzerland of England and was described by Thomas Gainsborough, when he stayed here on his honeymoon, as 'The most delightful place for a landscape painter this country can boast.' The poet Wordsworth also stayed here and Samuel Taylor Coleridge was inspired to write *The Ancient Mariner* after visiting the harbour.

A_ 8225. LYNMOUTH.

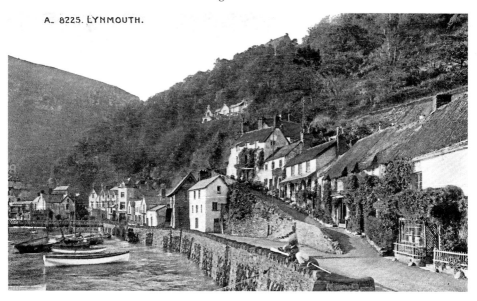

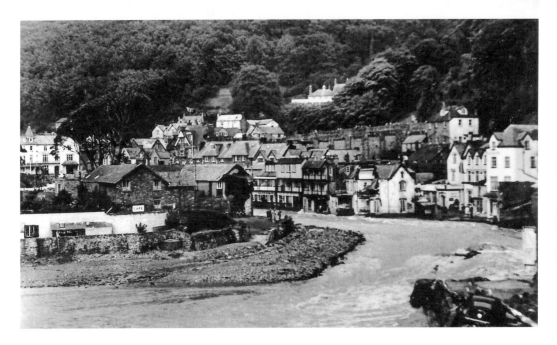

The 1952 Flood, Lynmouth

Both of these postcards show the devastating flood that hit Lynmouth on the night of 15/16 August 1952. A severe storm broke over the region with, it is estimated, over nine inches of rain falling over twenty-four hours. Floodwaters brought mud, boulders and tree trunks with them that cascaded down the rivers and converged on Lynmouth. A dam had formed with the debris, which suddenly gave way under the weight of the water and sent a huge wave of water straight into the town. From 7.00 p.m. water rose rapidly and by 9.00 p.m. it had turned into an avalanche. The water crashed through windows, doors and walls.

Over the course of that night more than 100 buildings had been destroyed, or severely damaged, together with twenty-eight bridges. Cars were washed out to sea and in total thirty-four people were killed, with a further 420 made homeless.

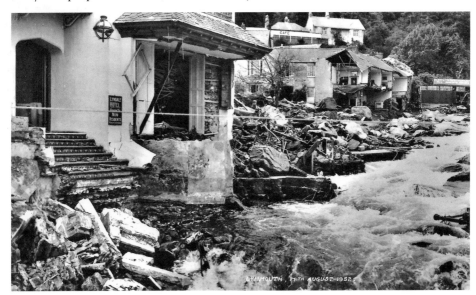

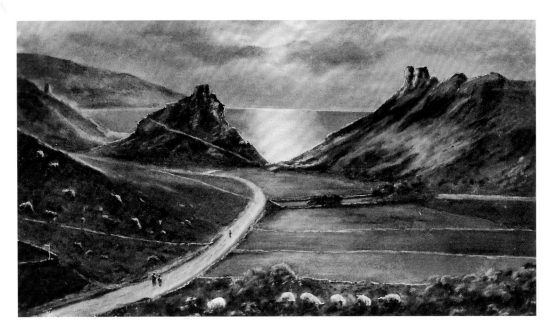

Lynton

The first hand-tinted postcard shows the Valley of the Rocks – a natural gorge between two hill ridges near Lynton. The geology of the valley is particularly noteworthy: among the oldest rocks from the Devonian period are found in Devon. This area was at the limit of glaciation during the last Ice Age, which helped create its rugged and dramatic rock formations. The valley is also noted for its wild free-roaming goats.

The second postcard shows St Mary's Church in Lynton. Three men can be seen sitting in the old stocks – presumably the picture is a posed one. Behind the three men is an elderly gentleman holding some form of beater. The man in the background wearing the top hat appears to be sitting on a tombstone. The men's hobnail boots are particularly interesting to see.

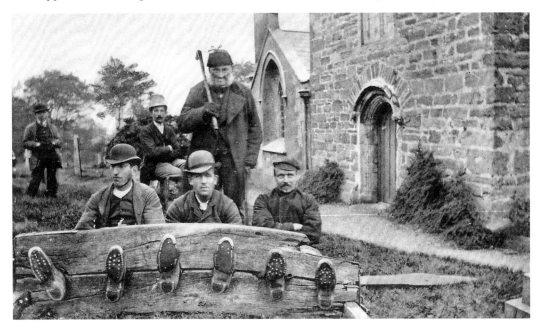

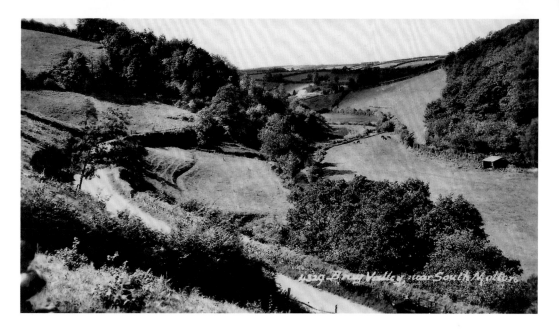

Bray Valley

Both postcards feature beautiful scenes from the picturesque Bray Valley, near South Molton and on the south western boundary of Exmoor. The River Bray runs through the steep sided valley, rising at Exmoor and flowing to 470 feet above sea level as it reaches the village of Brayford. The bridge shown in the second postcard may be Filleigh Bridge, but is difficult to clearly identify for certain.

The name Bray is derived from the Old English word *breg*, meaning 'brow of a hill'; there are references to the area being known as Braeg as far back as the tenth century. The postcards would be a charming souvenir to take away as a memory of the beautiful North Devon countryside.

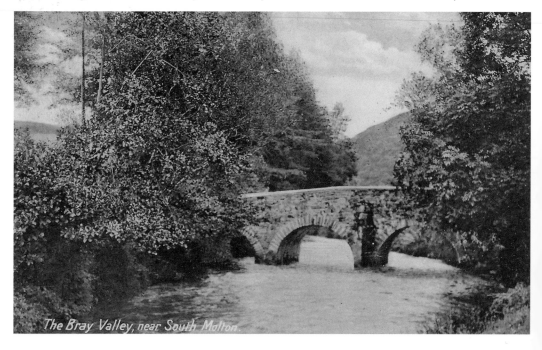

The Bray Valley, near South Molton.

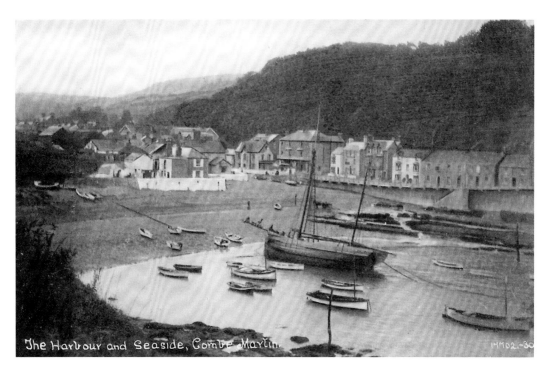

The Harbour and Seaside, Combe Martin

Combe Martin

The name Combe Martin comes from the Old English *cumb,* or *combe*, meaning 'wooded valley'. The 'Martin' part of the name is said to derive from the FitzMartin family, or alternatively from Martin de Tours. The FitzMartins were feudal barons of Barnstaple and descended from one of the supporters of William the Conqueror.

The first postcard shows the beautiful and sheltered small harbour which, until the end of the nineteenth century, was busy with fishing boats, coastal vessels and traders selling produce locally and on to Wales. Shipbuilding also took place here. Now mostly a tourist attraction, Combe Martin is in the *Guinness Book of Records* for having the longest main street in a village in Britain – nearly two miles long.

The second postcard shows The Parade in Combe Martin from 1918.

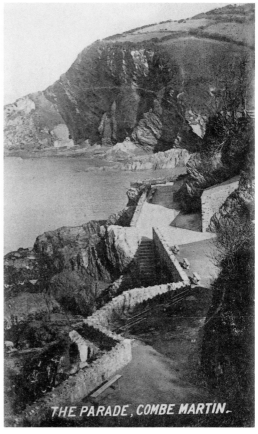

THE PARADE, COMBE MARTIN.

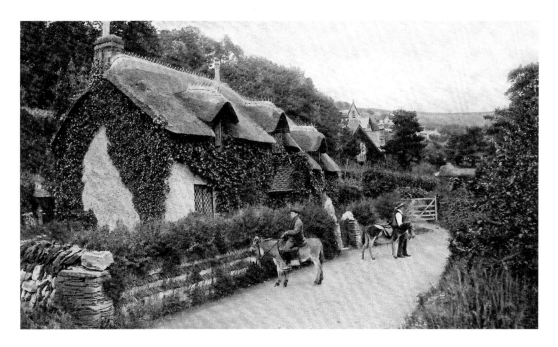

Lee Bay

Both hand-tinted postcards show two pretty thatched cottages in the beautiful little village of Lee Bay, between Ilfracombe and Woolacombe. The north facing cove was a prime spot for smuggling, with many a ship from overseas hoping to offload their cargo and avoid the customs. One of the most notorious smugglers from Lee Bay was Hannibal Richards. Moving to the village in 1789, he is said to have had a lookout at Sandy Cove. He must have been very successful at his business as he died aged eighty-five and is buried in Ilfracombe churchyard.

Not surprisingly, the area is part of the North Devon Areas of Outstanding Natural Beauty (AONB) and is known locally as Fuchsia Valley due to the wild fuchsias that grow in abundance in the hedgerows.

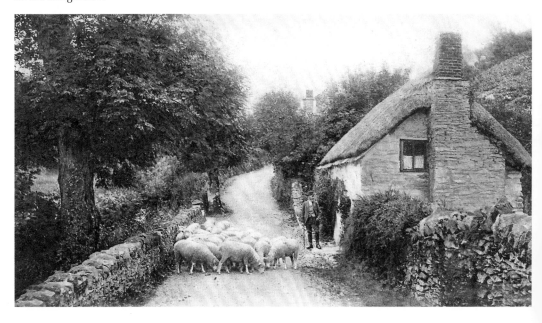

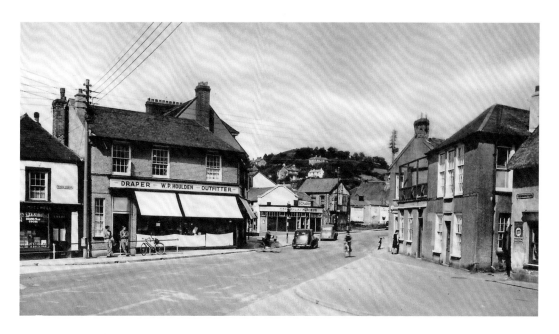

Braunton Square

These two postcards both show the Square in Braunton, a typical early Saxon village – the main industry had been agriculture for centuries. Braunton Great Field is one of only three remaining medieval open field strip systems in the country.

For centuries a large elm tree stood at the centre of the Square, then known as Cross Tree. This was the main spot in the village for many events, with public speakers often giving forth here. The town crier would stand here to inform the villagers of the latest news.

The first postcard shows the Square in the 1930s with W. P. Houlden's drapery shop on the corner of Caen Street. The second postcard from the 1960s has the same shop, now called Flair, a business that remained there for many years. It is now a surf shop. Ellis Butcher's is now a dry cleaners.

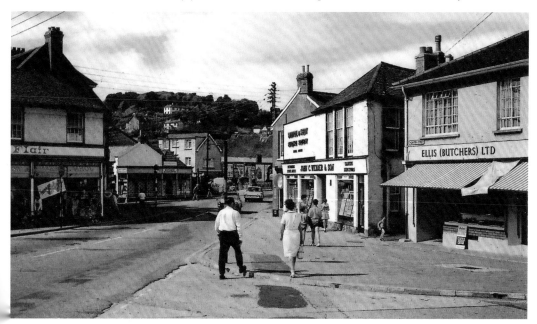

SECTION 6
ILFRACOMBE

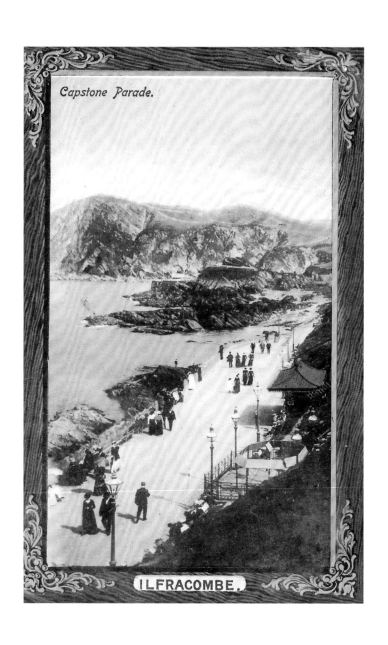

Capstone Parade.

ILFRACOMBE.

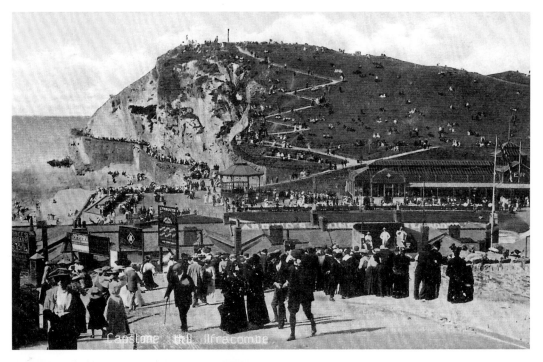

Capstone Hill, Ilfracombe

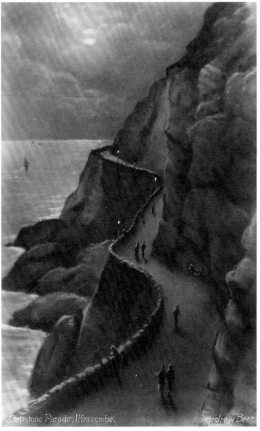

Capstone Parade, Ilfracombe. Andrew Beer

Capstone Hill

The walkway cut into the back of Capstone Hill was constructed between 1842 and 1843 as an unemployment scheme. It was said that Queen Victoria was concerned about the rising unemployment among working class men of the time and suggested that they be given manual labour tasks to improve their local environment. The walkway gives superb views looking out to sea and has always been a popular walk.

The first postcard, posted in 1910, shows how incredibly popular the town was during its heyday as a tourist attraction. Hundreds of people, dressed in their best summer clothes, can be seen here walking around Capstone hill, with many more sitting around the music stand towards the right of the picture. Some sort of event is taking place on the seafront to the left, which many are enjoying.

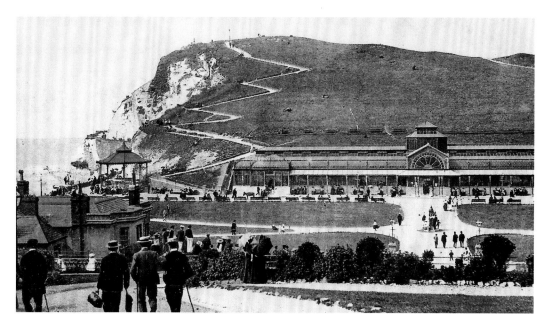

Capstone HIll

The picture on the front of this postcard shows Capstone Hill filled with people enjoying the summer weather. The Pavilion, with its glass wings, is clearly visible. The bandstand, seen here right on the seafront, has now been moved slightly further along to Runnymede Gardens. The card was written by a gentleman called Albert and sent to a Miss Durrant. On the back he tells of an incident during his stay, writing 'I have had a bit of bad luck last Friday week and cut my three fingers very bad. I was unconscious for three hours but they are better now.' He goes on to apologise that he has not written sooner but complains about the 'postal tax'.

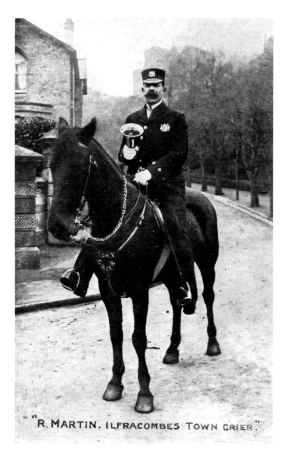

"R. MARTIN. ILFRACOMBES TOWN CRIER."

Ilfracombe Hotel and Town Crier

The second postcard shows the old Ilfracombe Hotel. It was the town's first purpose-built luxury hotel and was opened in 1867. It proved tremendously successful and within fifteen years it had significantly expanded. While visitors could stay in the comfortable rooms, there were cheaper rooms in the attics for their accompanying servants. With 210 rooms, it was considered one of the finest of its type in the country. The hotel boasted a large indoor heated swimming pool, electricity throughout (by 1903), and it was in a prime seafront position.

After the end of the First World War however, tourism was in decline and the hotel was loosing its glamour. It was finally demolished in 1976

The splendid postcard of the gentleman on horseback is that of a Mr R. Martin, the Ilfracombe town crier, taken in July 1918.

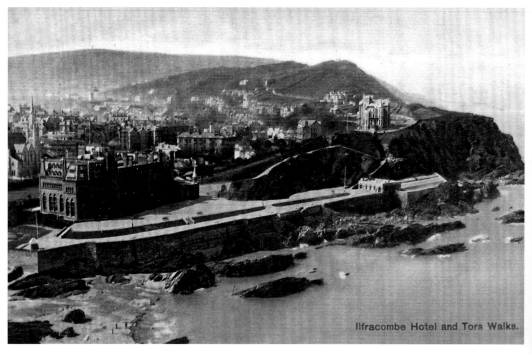

Ilfracombe Hotel and Tors Walks.

Old Ilfracombe and Raparee Cove

The first postcard shows Fore Street in Ilfracombe. This is one of the oldest parts of the town; some of the houses date back to the seventeenth century. Number 78 has an iron-studded door with the date of 1665 clearly visible. On the right Rock Terrace can be seen, with Bryant's Dairy further down on the left. The imposing sight of Hillsborough – 115 metres above sea level – can be seen at the end of the road.

The second postcard shows Raparee Cove, a small secluded cove to the east of Ilfracombe. It was the site of the shipwreck of the *London*, which sank during a storm in 1796. In 1997 human remains were discovered buried in a mass grave at the foot of the cliffs and it is believed that the *London* was possibly bound for Bristol and had been loaded with French prisoners or slaves.

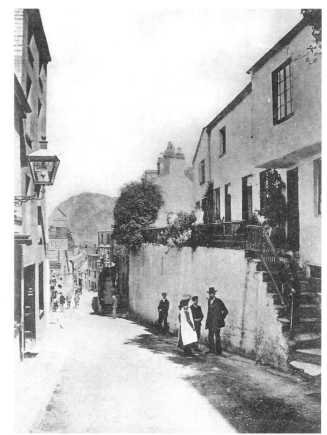

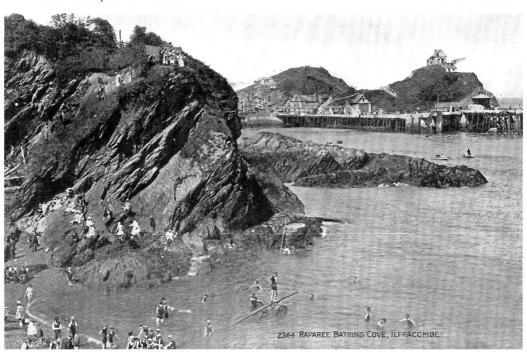

2364 RAPAREE BATHING COVE, ILFRACOMBE.

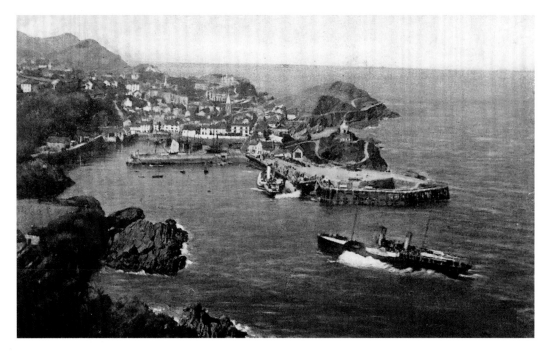

Lantern Hill

Lantern Hill was not always as it is now. Originally, at high tide the sea would come in and cover the lower rocks, turning it into a tiny island. Gradually over time the sea brought in boulders and large rocks, filling in the gaps until it became as we know it today.

St Nicholas Chapel, which sits atop Lantern Hill, was built as a place of worship in 1321. A lantern was kept alight to guide shipping into the harbour from the Middle Ages, it is said to be the oldest lighthouse in the country. After the Dissolution of the Monasteries in 1540, the chapel became the home of the lighthouse keeper. Despite its small size, between 1853 and 1871 a Mr John Davey, who was the resident lighthouse keeper, raised a family of fourteen children.

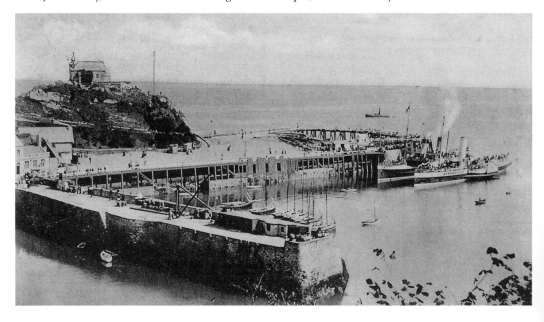

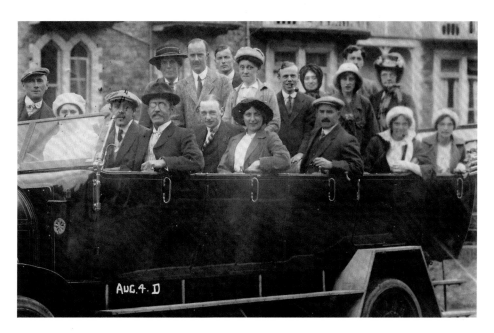

A Charabanc Full of Holidaymakers, 1918

Enterprising local photographers would often make a decent business opportunity by taking various posed photographs of holiday makers enjoying different activities (or of any scenes they wanted to remember) and turning them into postcards. This must have been the case for this particular example, as the text on the back reads 'Dear Rose, How do you like this? They are all from our boarding house except the front row.' No mention is made of which boarding house it was. The lady doing the writing, who signs off 'Love Connie' goes on to make a comment about the recently declared war, saying 'Isn't this war dreadful? It is making things so quiet here.' Considering the fact that Britain had only declared war on Germany three days prior to the postmark on the card, it is surprising that any difference could be remarked on that quickly.

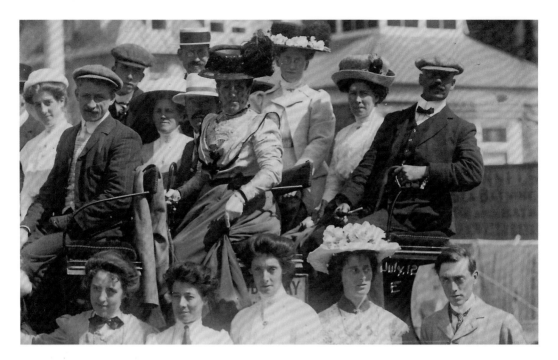

Day Trippers

The first postcard is dated 1912 and shows a group of smartly dressed people, presumably about to go on a day trip. It is difficult to see if they are on a fashionable, modern open-topped omnibus or horse drawn transport. Just behind them it is possible to make out a sign for the Tunnels beaches in Ilfracombe, with a reference to sea bathing.

The second postcard shows a group enjoying a day out in Knills Victory Cars. Frank Albert Knill (1868–1937) was the proprietor of the Hotel Cecil (on Wilder Road, Ilfracombe) and was also listed on his business card as 'Automobile Engineer'. For several years he successfully ran Knills Victory Cars. Quite a few postcards exist that show groups of smiling people enjoying a trip out somewhere in the countryside.

Hotel Cecil was destroyed by fire one evening in January 2001 and later replaced by Wildersmouth Court, a block of private flats.

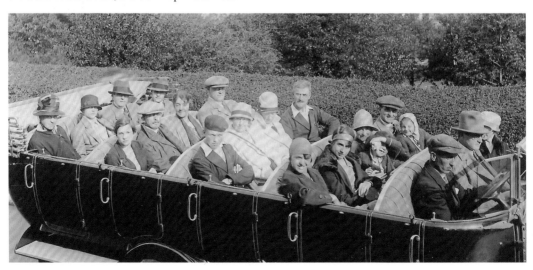

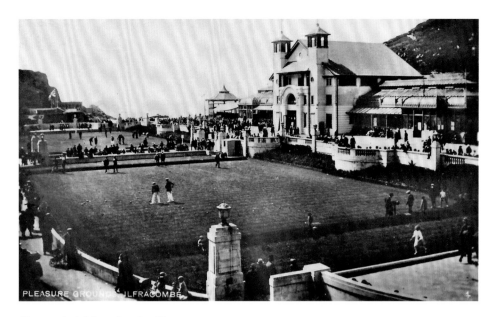

Ilfracombe's Victorian Pavilion

The well-remembered Victoria Pavilion Theatre was built to celebrate Queen Victoria's Golden Jubilee in 1887. The large theatre in the centre, with its twin towers, was flanked by large ornate glass pavilions either side. The second postcard shows how the glass buildings contained raised flower beds that, due to the heat inside, could flower all year around. Grape vines grew up the walls and along the roof, clinging to the iron work. Seating is along one side with the far end laid out for music concerts, which would take place at various times throughout the season.

In 1925 the pavilion was rebuilt as a concert hall. However, twenty-four years later, on 28 June 1949, the central building caught fire and was badly damaged. The ornate glass side wings were demolished in the 1960s and replaced with ugly modern stone blocks. The entire building was finally demolished in 1994.

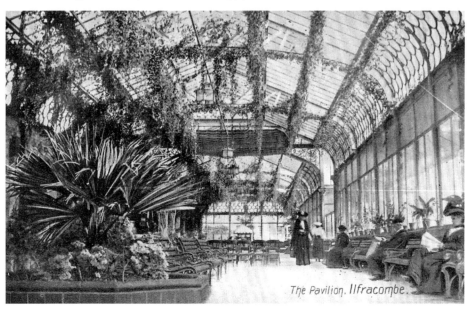

SECTION 7

TOWNS AND VILLAGES TO THE SOUTH OF BARNSTAPLE

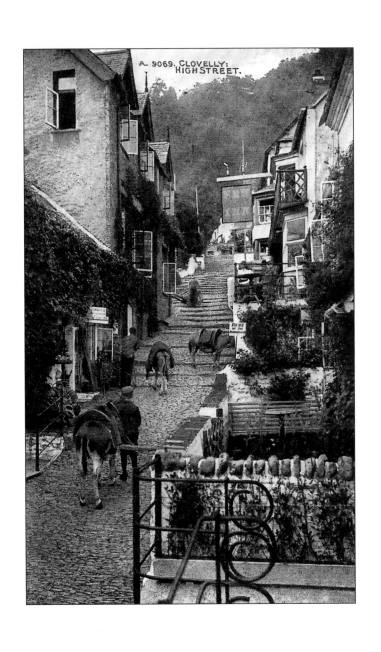

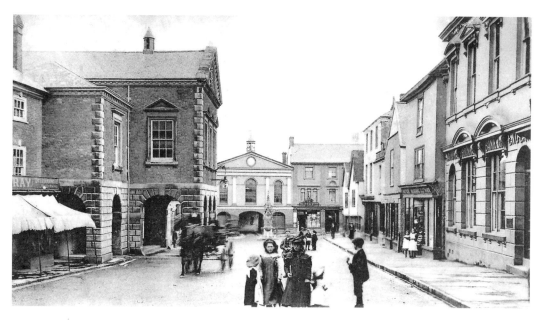

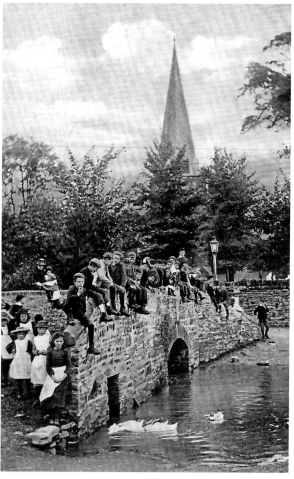

Swimbridge and Torrington

Torrington is a market town in a picturesque setting, but like many inland towns it has diminished in importance with the decline of the market and local industries. In 1801 the town was described as 'rich and populous'; glove making was a major source of employment. Torrington was the site of the last major battle of the Civil War when the church was blown up, probably accidentally, with 200 prisoners inside. The Market House, built in 1842, faces down High Street and can be seen in this postcard from 1905. Also prominent in the postcard is the town hall; it was constructed in 1861 on the site of an earlier building, but kept the Georgian appearance. The other postcard shows Swimbridge, which at the time of Domesday Book was known simply as 'bridge' and was held by Saewin the priest. Centuries later it became known for another clergyman – Parson Jack Russell, who gave his name to a breed of terriers. Although more famous for hunting than preaching, he was a popular parson and his funeral at Swimbridge in 1883 was very well attended.

Clovelly Harbour

These two postcards show the harbour at Clovelly, one of the most picturesque Devon villages with its extremely steep, cobbled street leading down to the harbour. George Cary, one of seven generations of Carys at Clovelly, built the massive stone pier here, making it the only safe harbour between Appledore and Boscastle. Although a car did drive down the street in 1920, no motor vehicles are now permitted and deliveries are made by sledge. Clovelly was a fishing village, especially famous for its herrings. At one time there were sixty or seventy boats involved in herring fishing. Now there are just two herring fishermen, but there is a Clovelly Herring Festival that is held in November. Until the mid-nineteenth century the village was little visited, but then Charles Kingsley's *Westward Ho!* was published, in which Clovelly and the Carys featured. Charles Dickins also wrote about it in *A Message from the Sea*, which also attracted tourists, including many artists.

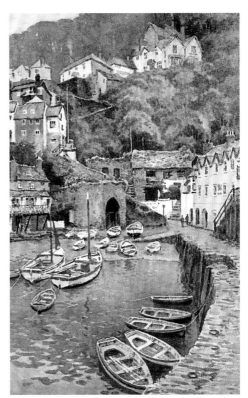

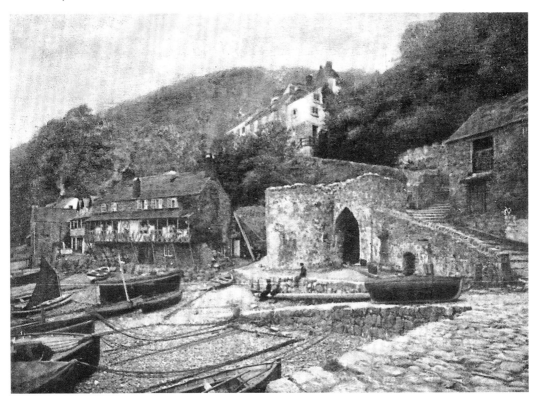

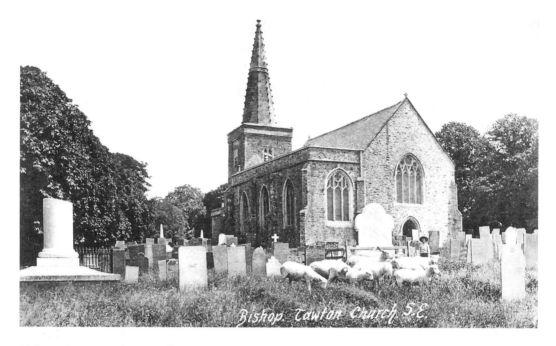

Bishops Tawton and Tawstock

These two postcards show the villages of Bishops Tawton and Tawstock (a few miles from Barnstaple on opposite sides of the river). Bishops Tawton was a valuable part of the Bishop of Exeter's property and medieval bishops had a residence here, traces of which remain in the farmhouse next to the church. The church is one of the few in Devon with a medieval spire, but the chancel, south porch and vestry were rebuilt in 1860. The church at Tawstock is in the grounds of Tawstock Court. It is largely fourteenth century, although the core may date from the twelfth century. It is unusual for the position of the tower to be over the crossing. The interior is notable for the large number of monuments, many of which relate to the Bourchier and Wrey families who owned the estate for centuries.

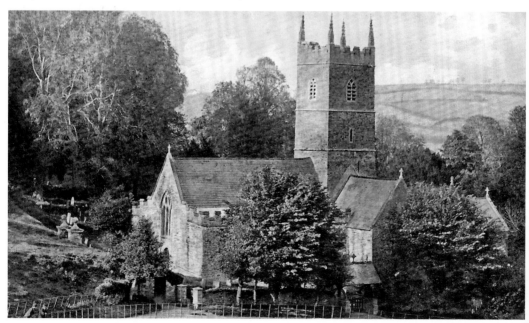

North and South Molton

North Molton, pictured in this postcard dated 1905, was once a thriving town but it declined when it lost its main trades. It was a centre of the woollen industry, but that vanished as a result of the Napoleonic Wars. From the sixteenth to the nineteenth centuries, iron and copper mining was also carried out in the area. A guidebook from the 1870s states that there was a copper mine in the area that produced the richest ore of any mine in Devon; for a few years gold was also mined. The medieval church, restored in the nineteenth century, has an impressive tower. On the south side is an original figure of the Virgin and Child, which somehow survived the Reformation. The other postcard shows a view of South Molton in its rural setting. Both towns take their name from the River Mole.

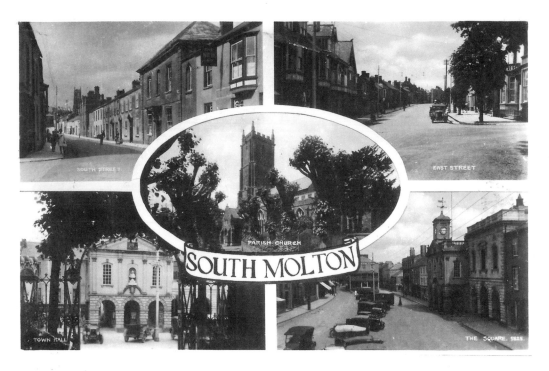

South Molton

The first postcard provides a variety of images of the prosperous market town South Molton, located 11 miles from Barnstaple and known as the gateway to Exmoor. South Molton was on the main road to Taunton. The coaching trade was very important to the town, as was the woollen industry, but both declined in the nineteenth century. Agriculture was also important to its prosperity and the Pannier Market was built in 1863 next to the guildhall. The church shown in the centre of the postcard is a fifteenth-century building that was enlarged and restored in the nineteenth century. Until 1751 the tower was crowned with a spire. The second postcard is a view of South Street with the significant date of August 1914.

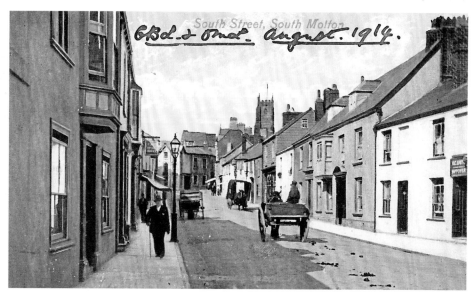

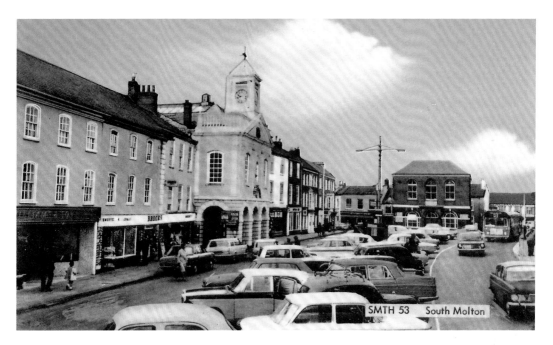

South Molton Square

The next two postcards of South Molton show the Square (or Broad Street) taken many years apart. This was the original market place where, until the Pannier Market was erected in 1863, local produce was sold in the open air. To the left of the postcard above, dated 1976, is the town hall. This was completed in 1743 and was constructed partly from materials taken from the Grenville family house at Stowe in Cornwall, which was being demolished at the time. There is a bust of the local benefactor Hugh Squier on the front of the building. Born in 1625, he provided the town with a grammar school and bequeathed funds for the improvement of the town. The postcard below, with the post office in the centre, dates from 1911. This was opened in 1888 in the former Corn Market.

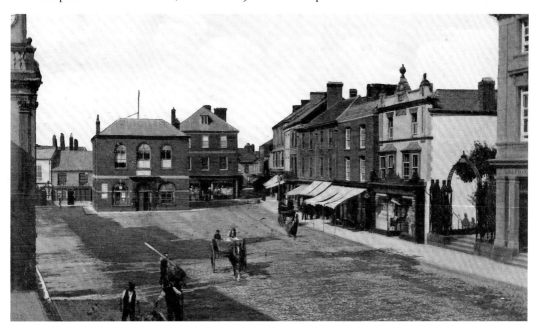

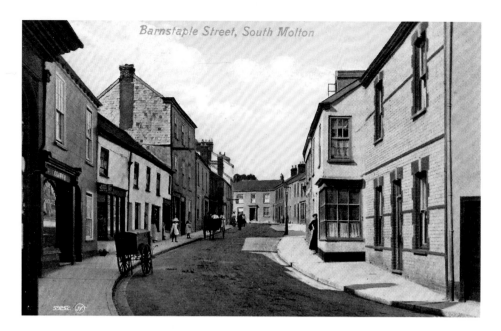

Barnstaple Street, South Molton

Here are two more lively street scenes from South Molton – both of Barnstaple Street. The earlier postcard, with the neatly dressed schoolgirls in their pinafores and hats, is from 1905. The other view is from August 1918. In May 1915 about 120 men of the Depot Battalion, 6th Devon Regiment, stationed at Barnstaple, marched to South Molton where the mayor gave a speech encouraging men to enlist. They set off at around 8.30 a.m., passing through Landkey and Swimbridge and arriving in South Molton at around 1.00 p.m. where refreshments were provided and then they proceeded to the station to get the train back to Barnstaple.

The Red Lion Inn, seen in the 1905 postcard, was one of nineteen inns and taverns in South Molton in 1850, when the population was around 4,800. There were also two temperance hotels, one of which was in Barnstaple Street.

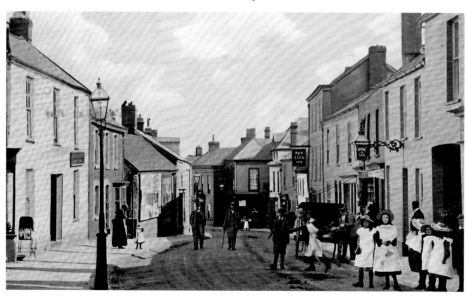

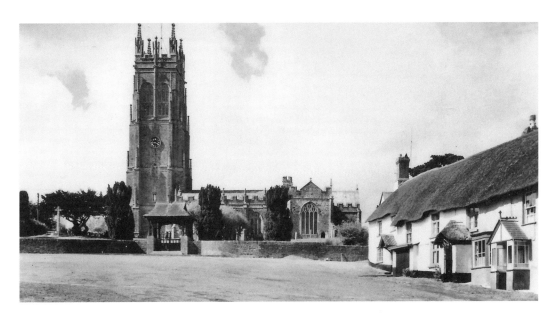

Chittlehampton and Umberleigh

The first postcard shows the attractive square at Chittlehampton which, unusually for the area, still has several thatched buildings. The church is magnificent and has one of the finest towers in Devon – 115 feet high and crowned with eight openwork pinnacles. It's possible that the church is so grand because of its dedication to the Celtic saint and martyr Urith, or Hieritha, who was slain by Saxons and buried here; her shrine was a site of pilgrimage. The church was rebuilt *c.* 1500, but there were also many alterations to it in the nineteenth century.

The second postcard is of Umberleigh in 1905, one of the places on the railway line from Barnstaple to Exeter. It is part of the parish of Atherington, but it is King Athelstan that is said to have built a palace on his manor here with an adjoining chapel. At the time of Domesday it was the sole possession held by the Holy Trinity Church, Caen.

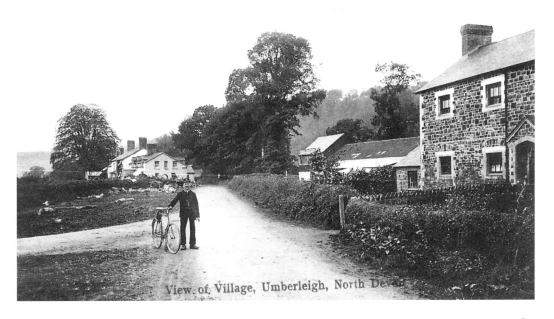

View of Village, Umberleigh, North Devon

SECTION 8

BIDEFORD

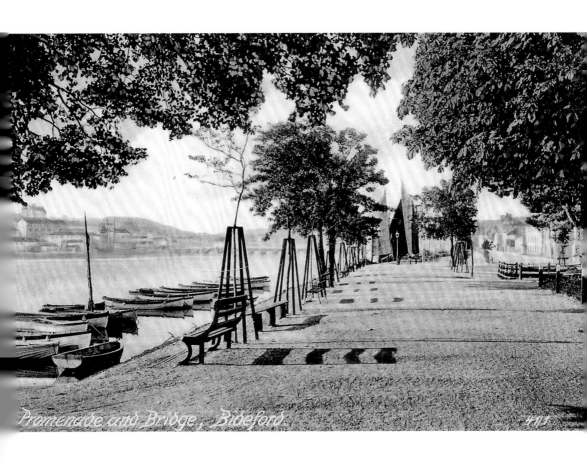

Promenade and Bridge, Bideford

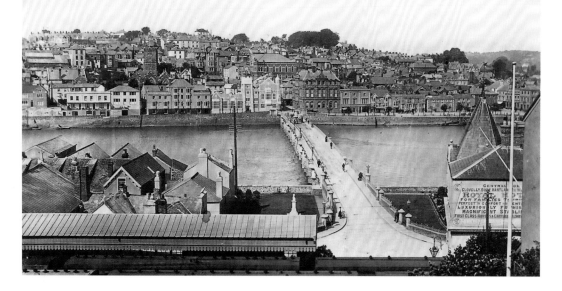

Bideford Bridge and Promenade

The first of these Bideford postcards gives an impression of the town in December 1913. It is taken from East-the-Water above the railway station, which was established there in 1872 when the line was extended to Torrington. Bideford was one of the many places that lost its passenger train service at the time of the Beeching cuts in 1965, although freight continued until 1982. In the grass area to the left of the bridge the bust of John Pine-Coffin can be seen, which was placed there in 1894. John was a local landowner, county councillor and magistrate. Below the station and to the right is the rear of the Royal Hotel. This was opened in 1888, but incorporates a merchant's house from the late seventeenth century. The second postcard, dated 1905, shows the promenade with its young trees and the bridge in the background.

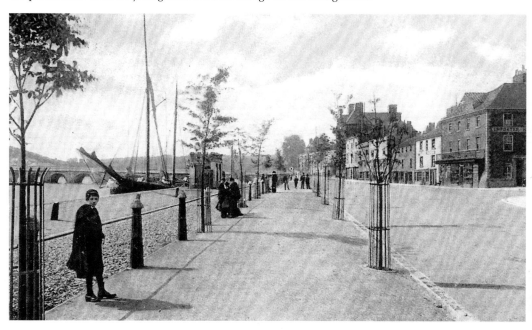

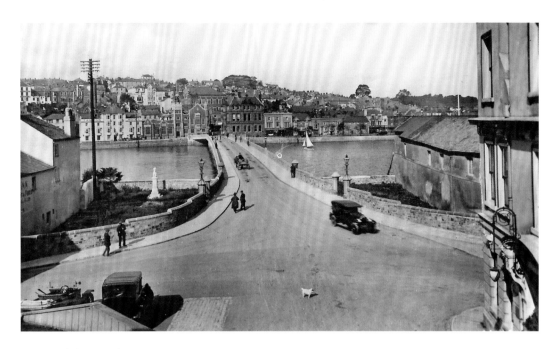

Bideford Bridge

Here are two more views of Bideford Bridge, the first taken from near the railway station. The date is unknown, but the cars indicate it is later than the previous postcard. The origin of Bideford Bridge is not certain, but it probably dates from around 1280. It was originally a timber bridge, but was later rebuilt in stone. It is famous for its twenty-four arches, which are all of different sizes due to the mixed dimensions of the original timber that the stone was placed around. It has been greatly altered and widened over the centuries; the early pictures show the bridge before a major alteration in 1924/25. The greatly increased volume of traffic in the following years led to the collapse and subsequent repair of two arches in 1968.

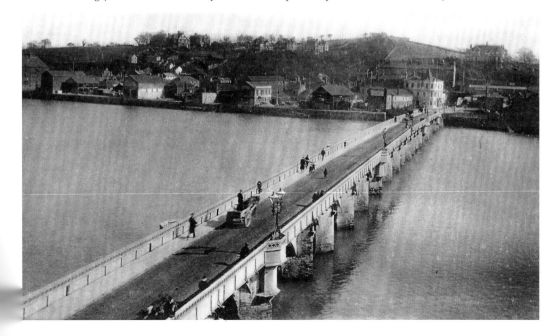

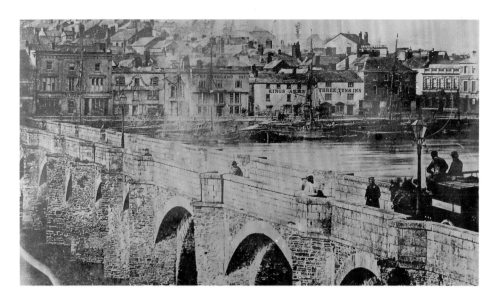

Bideford Bridge and Nearby Pubs

Here is another postcard of the bridge. It is from a photograph of 1863, which clearly shows how narrow the roadway was before the later nineteenth and twentieth century alterations. Across the river on the quayside the four adjoining public houses can be seen that once occupied the site. In the seventeenth century the Three Tuns was Bevill Grenville's town house, but it has undergone many changes since then and has long ceased to be a public house. Next to the Three Tuns is the King's Arms, another much-altered old building, and next to that is the Newfoundland Inn. This was also originally a private house, becoming an inn in the early nineteenth century. The name reflects the importance of Bideford's Newfoundland fishing trade. It was renamed the Old Ship Tavern, seen in the second postcard, reflecting the popularity of Charles Knigsley's novel *Westward Ho!* Later it became a restaurant called The Rose of Torridge, named after the heroine of Kingsley's book.

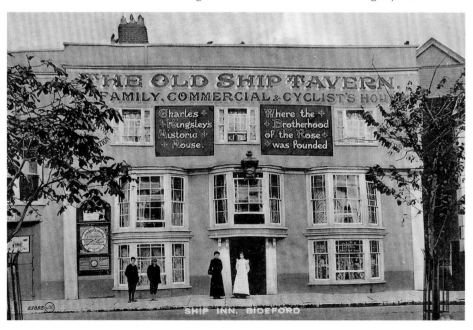

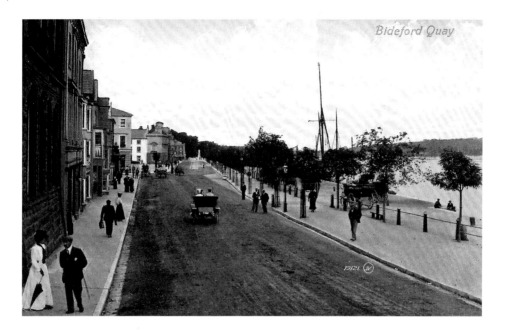

Bideford Quay

From the River to the High Street

The first of these postcards provides an attractive view of Bideford Quay in the early twentieth century. In the distance at the end of the road the Kingsley statue can be seen, which was paid for by subscription and unveiled in 1906 as a permanent reminder of the importance of Kingsley's novel to Bideford. Charles Kingsley rented a house in the town in 1854 in order to write his novel, which was set in the local area and became a bestseller. Many visitors came to see places mentioned in the book, which notably described Bideford as, 'The little white town of Bideford which slopes upwards from its broad tide-river...'

The more recent second postcard shows the busy High Street, one of the steep streets leading up from the river. The sign for Bromleys is prominent, which had a café in Bideford as well as Barnstaple at the time.

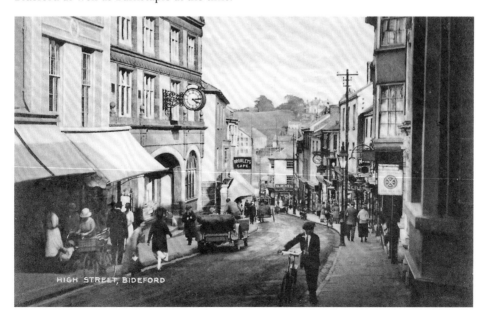

HIGH STREET, BIDEFORD

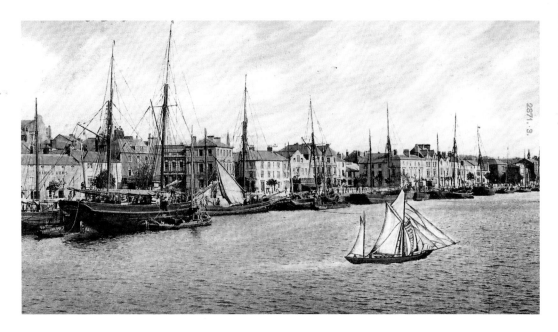

The Quay

These two postcards from the early 1900s provide picturesque views of the Quay. This area has been much altered over the centuries. The southern end of the old quay was near the Kings Arms; a new quay was begun in 1663, but there have been several alterations and extensions since then. The town belonged to the Grenvilles for centuries and Bideford seamen manned Sir Richard Grenville's expeditions to Carolina and Virginia. Trade with the new colonies made Bideford prosperous, especially the Newfoundland fishing trade and the new tobacco crop. In around 1700 Bideford became the chief port of North Devon, busier than its old rival – Barnstaple. Although trade declined in later centuries, Bideford remains a working port. In 1907 a water carnival was held on the river, after dark fairy lights lit the Quay and 'many illuminated and decorated craft glided up and down the river'.

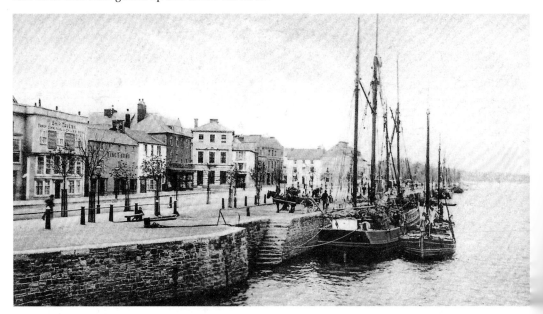